GLASGOW SHOPS PAST AND PRESENT

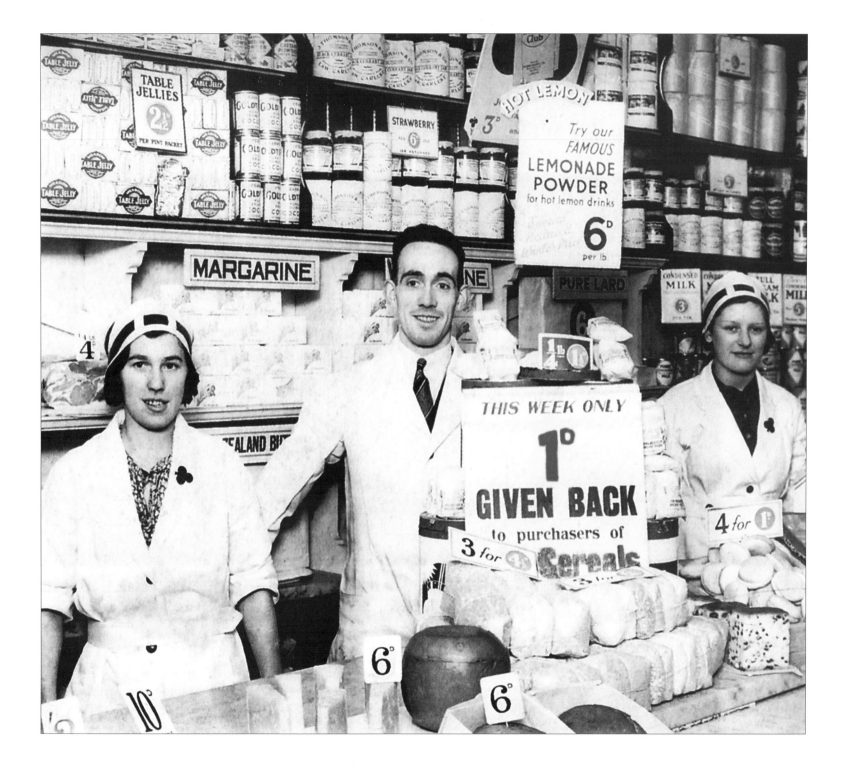

Carol Foreman

GLASGOW SHOPS
PAST AND PRESENT

BIRLINN

Opposite title page.
Interior of Lipton shop, and staff, in Garscube Road
in 1931. The placard invites customers to 'Try our
famous lemonade powder'. There is a special offer on
cereals for one week (a whole penny given back). The
top shelves contain packets of blancmange and table
jellies, next to which is strawberry jam.

❧

First published in 2010 by
Birlinn Limited
West Newington House
10 Newington Road
Edinburgh
EH9 1QS

www.birlinn.co.uk

ISBN: 978 1 84158 903 9

British Library Cataloguing-in-Publication Data
A catalogue record for this book is available from
the British Library

Designed and typeset by Mark Blackadder

Printed and bound by Bell & Bain Ltd, Glasgow

CONTENTS

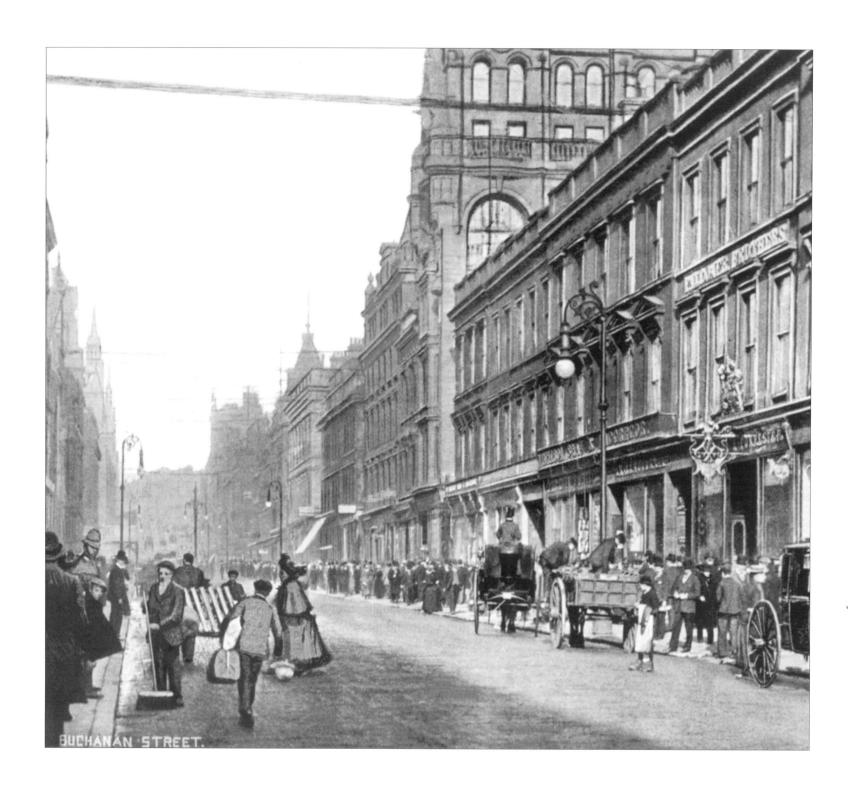

BUCHANAN STREET.

INTRODUCTION
AND ACKNOWLEDGEMENTS

Before the advent of shops, goods were sold within burghs at markets and fairs. People traded from carts, trays and wooden stalls usually set up around the Mercat Cross. In Glasgow this stood at the intersection of Rottenrow and Drygate until the fifteenth century after which it was moved to the intersection of High Street, Gallowgate, Trongate and Saltmarket.

It was not until the sixteenth century that the evolution from stalls to shops began with the introduction of permanent booths for trading. A century later came fixed shops, many operating from the ground floor of the trader's home. This led to rows of shops lining streets, much as we know it today. In Glasgow, many of the shops were arcaded, especially those around the cross.

Although by the start of the nineteenth century Glasgow's shops were well-established, diverse and catered for all classes, many people still relied on hawkers and street traders. The main shopping areas were around High Street, Gallowgate, Saltmarket, Trongate, Bridgegate and Candleriggs. King Street was the provisions centre. Glasgow's shopkeepers were innovative and when grocer James Hamilton installed gas lighting in his shop in Trongate in 1818, it created a sensation as it was the first such illumination.

As the nineteenth century progressed, shopkeepers gradually moved west as Glasgow was growing in that direction. When the Argyll Arcade opened in 1828 it linked Argyle Street with Buchanan Street which then became the most fashionable and exclusive promenade in the city. The Victorian age saw the rise of department stores and by the mid-1850s Glasgow had stores such as Anderson's Polytechnic, Wylie & Lochhead and Arthur & Fraser. Later, with the introduction of department stores in Sauchiehall Street, it superseded Buchanan Street as the favoured shopping thoroughfare.

Today, Glasgow is the largest and best retail centre in the UK outside London. *Glasgow Shops Past and Present* contains a fascinating selection of photographs of shops and advertisements ranging from the eighteenth century to the present day. Emphasis is on the past, and the vintage photographs show how people shopped in times gone by and what they were able to buy.

Opposite. Buchanan Street in 1890.

The book is divided into five parts – Food, Non-Food, Shopping Centres, Chain Stores and Department Stores. The photographs shown in the Food and Non-Food sections are arranged by trade and, where possible, dates of the photographs are given. In the centre of the book are coloured advertisements of items relating to the food and non-food sections.

Part 1 begins with photographs of grocers, the largest group, containing household names such as Lipton, A. Massey & Sons, Templeton's and William Low, where groceries were bought before the emergence of supermarkets. As well as those big names, there are photographs of smaller family-run businesses in various localities. Although not principally involved in the grocery trade, photographs of various Co-operative shops are included in that section.

Next come dairies, bakeries, tea-rooms and cafés, featuring names like the City Bakeries and the United Co-operative Baking Society. Of interest is a rare photograph of the Jewish Callander's Bakehouse in the Gorbals. In addition to photographs of cafés such as Coia's in Duke Street and the Premier in Main Street, Bridgeton, there is a photograph of Cranston's, the world's first

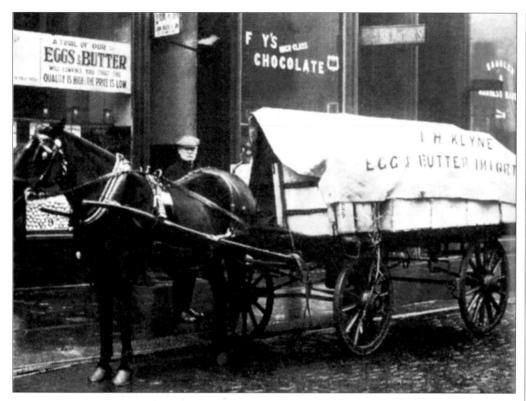

🐾 I. H. Klyne's grocery shop in Norfolk Street in the Gorbals *c.* 1930. Mr Klyne was an egg and butter importer and a sign on his shop window states that a trial of both items will convince that the quality is high – the price is low.

tea-room, that began at the corner of Queen Street and Argyle Street.

Fruit shops come next, Malcolm Campbell's being prominent. The section ends with confectionery and along with old favourites such as R. S. McColl and Birrell is Glickman in London Road, Glasgow's oldest sweet shop.

Part 2 covers more or less all shops not connected with food and after two rare old photographs of Jewish shops in the Gorbals, it begins with clothing and old favourites such as Forsyths, Paisleys and Hoey's. An interesting new name is Hellfire Alternative Clothing. Shoe shops come next followed by jewellers such as Chisholm Hunter and James Porter & Sons, the oldest inhabitant

of the Argyll Arcade. There are 'before' and 'after' photographs of these shops. Beauty and hairdressing follow with photographs of fondly remembered shops like Fusco's and Scobies.

Photography and opticians are grouped together, with vintage photographs of T. & R. Annan, Charles Frank and Lizars, founded in Glasgow in 1830 by John Lizars. Chemist shops are next, one featuring homeopathy nineteenth-century style.

On the leisure side are sport and music ranging from Greaves Sports to Glasgow's oldest music shop, Biggars, founded in 1867.

Representing furniture are names from the past like Bows in High Street, Gardners in Jamaica Street and Wylie Lochhead in Buchanan Street, once Scotland's premier furnishing establishment whose building now forms part of Frasers' department store.

Newsagents, tobacconists and the city's oldest trading company, John Smith & Son, come next with Tam Shepherd's Joke Shop, Miller's Art Shop and Hay's Pet Shop ending the section.

Part 3, Shopping Centres, covers the Argyll Arcade, the earliest covered shopping arcade in Scotland and the largest specialist jewellery outlet in Britain, if not in Europe. Newer centres such as Princes Square, Buchanan Galleries and the St Enoch Centre also feature.

Part 4 highlights the chain stores of Boots, Woolworths and Marks & Spencer plc which opened its first shop in Glasgow in 1919 in Argyle Street.

Part 5 deals with department stores,

Glasgow at one time having more than any other city in Scotland, or possibly in Britain. Today, only two survive from the past, Frasers and Watt Brothers. *Glasgow Shops Past and Present* features these as well as previously famous names such as Copland & Lye, Pettigrew & Stephens, Arnotts and Lewis's. The list is not comprehensive, merely representative.

To write a book such as this involves countless hours of sourcing suitable photographs and searching for information about them. More than half of the images are from my own collection built up over many years. Others are from friends with similar collections. Eleven are from Glasgow Regional Archives. The Scottish Jewish Archives Centre in Garnethill Synagogue provided information as well as rare photographs of Jewish shops in the Gorbals. Willie Don gave me access to the archives of the Scottish Food Trade Association. Family businesses such as Greaves Sports, Miller's Art Store, James Porter & Sons, Robert Graham, Glickman, Crolla and Coia, allowed me to use photographs from their archives as did Black & Lizars. Princes Square, Buchanan Galleries and the St Enoch Centre also provided photographs.

With the exception of the photographs of Glickman and Mr Sweet taken by Jim Barker, all the modern photographs were taken by Alan Ferguson to whom I am indebted as he tramped round Glasgow for weeks on end, often very early in the morning so that he could get shots of shops without people walking past them.

I would like to thank Hazel Reid for her

high standard of editing, Editorial Manager Andrew Simmons for his invaluable guidance and for keeping me up to the mark on deadlines and Mark Blackadder for his customary dedication to merging the images and text together creatively as he has done in my previous books.

The Queen Arcade in the early 1960s. Built in the mid-nineteenth century, it was one of several small shopping arcades that existed in Glasgow. Only the Argyll Arcade remains. Queen Arcade, which ran from Renfrew Street to Cowcaddens, was a continuation of Wellington Arcade that was demolished in 1930 when Woolworth acquired the property. The Queen Arcade closed in 1966.

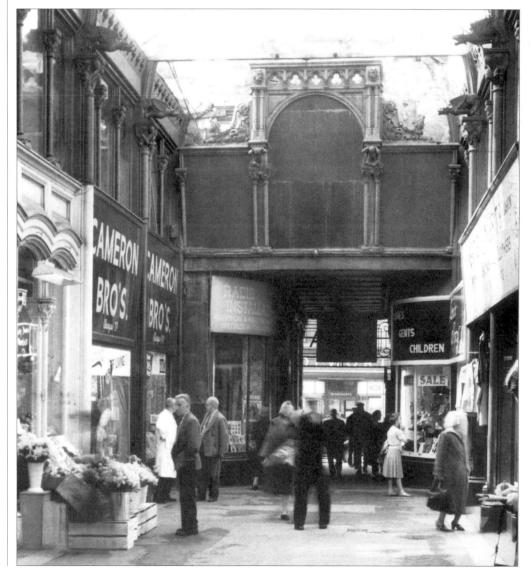

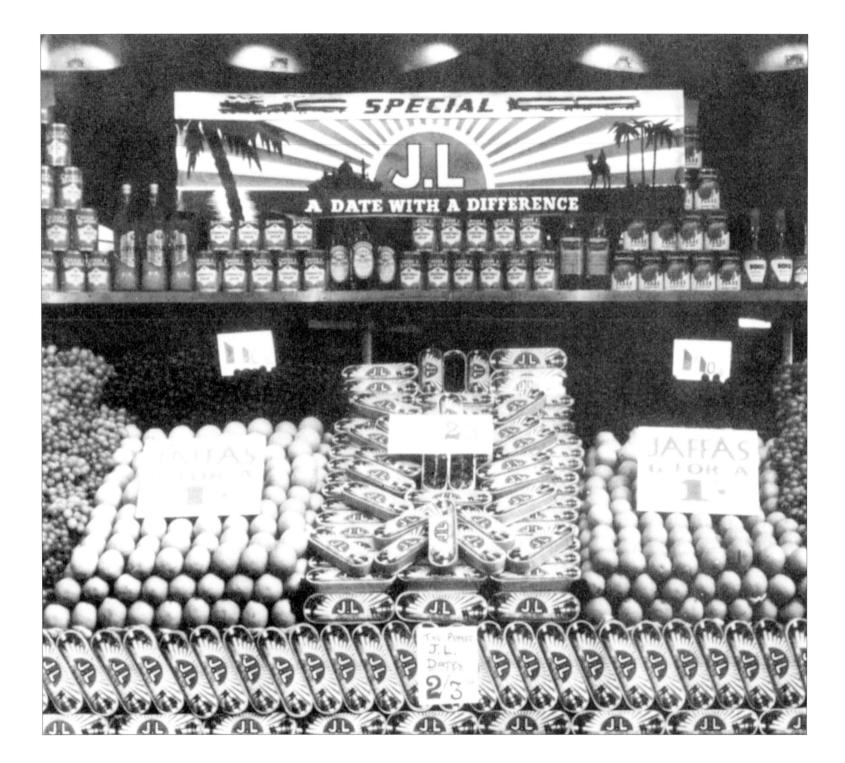

PART 1
Food Shops

Glasgow has always had an abundance of grocery stores, both private and multiple. The most famous was Lipton, a name that was known worldwide and can be said to be the forerunner of the modern supermarket chain. The Lipton story began when Thomas Lipton, born in Glasgow of Irish parents, opened his first grocery shop in the city in 1871. His success was based on bulk purchasing, a limited range of goods and selling at cut-rate levels with low profit margins. He was also an innovative advertiser.

Lipton had left school at the age of ten to help support his family. After working for a few companies he became a cabin boy on the Burns Line that ran between Glasgow and Belfast. He loved the job and the seafaring atmosphere but was dismissed for allowing a cabin lamp to smoke and discolour the ceiling's white enamel.

In 1865 he sailed to America and, unable to find work in New York, he ended up working in the Virginia tobacco fields. He then worked on a rice plantation in South Carolina. A couple of years later he returned to New York where he got a job as an assistant in a grocery store. There he learned the trade and became conversant with the American selling and advertising techniques that became his trademark.

Lipton returned to Glasgow in 1869 and began working in his parents' grocery shop in Crown Street where his grand plans did not meet with approval. His father's comment was: 'No Tom, we'd be getting above ourselves'.

On his 21st birthday, after working for his father for two years, Lipton opened his own shop at 101 Stobcross Street in Glasgow where he worked for eighteen hours a day, often sleeping in a makeshift bed under the counter. To cut out the middleman, he bought his produce directly from Irish farmers and went down to the quay himself to collect his provisions off the Irish boats, bringing them back to his shop in a hand-cart.

In 1876 Lipton moved to larger premises at 21/27 High Street where the butter counter was described as a large horseshoe shape that was served by twelve assistants. The shop was an instant success and a few months later he opened magnificent premises in Jamaica Street. Other shops followed in Glasgow and by 1882 he had shops in Dundee, Paisley, Edinburgh and Leeds.

Clever advertising paid a major part in Lipton's success. He employed Willie Lockhart, a leading cartoonist of the day, to produce weekly posters for him, most portraying pigs being taken to Lipton's Market. The opening of each new shop brought newspaper adverts, posters and parades of pigs being driven through the streets to his shops, resulting in new customers. By the 1880s Lipton had started selling tea. He had his own tea blenders and his tea was made up into half-pound and quarter-pound packets; it was the general practice in the trade to sell tea from open chests behind counters. To cut out the middleman he purchased tea estates in Ceylon and began growing his own tea which he packed in brightly-coloured, eye-catching packets bearing the slogan 'Direct

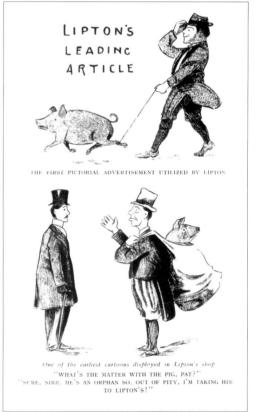

THE FIRST PICTORIAL ADVERTISEMENT UTILIZED BY LIPTON

One of the earliest cartoons displayed in Lipton's shop
"WHAT'S THE MATTER WITH THE PIG, PAT?"
"SURE, SIRR, HE'S AN ORPHAN SO, OUT OF PITY, I'M TAKING HIM TO LIPTON'S!"

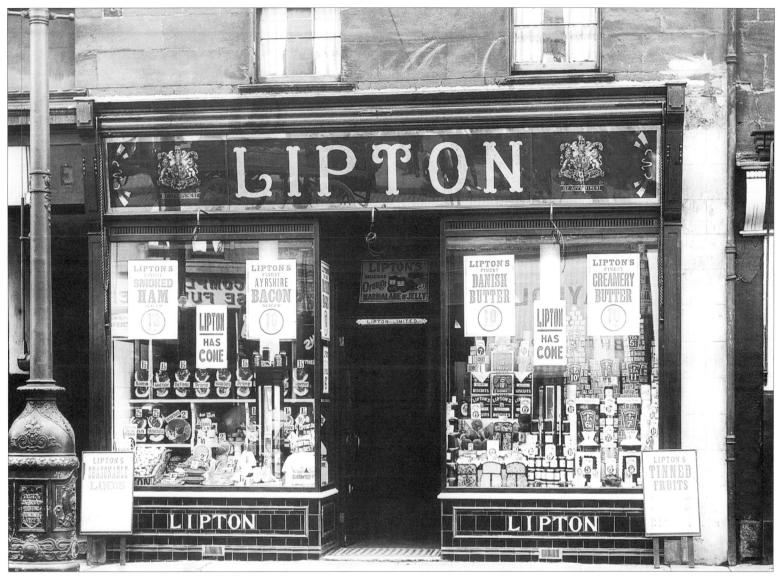

❧ *Opposite top.* Lipton's first shop at 101 Stobcross Street.

❧ *Opposite bottom.* Two of the earliest cartoon advertisements displayed in Lipton's shop. Initially they all portrayed pigs. The upper one was the first pictorial advertisement used by Lipton, the bottom one shows Pat, an Irishman with a pig in a sack that he says is an orphan and out of pity he is taking it to Lipton's.

❧ *Above.* While today, supermarkets have branded and own-label goods, Lipton's wares all appeared to be sold under the Lipton name, as is shown in the window display in this 1935 photograph of the Lipton shop at 105 Crown Street. There's Lipton Orange Marmalade & Jelly, various Lipton teas, Lipton Biscuits, Lipton Danish butter and a wonderful display of Lipton hams, Special, Prime, Value, Finest and Superior that sells for 1s 3d per lb.

from the Tea Garden to the Teapot'. He then introduced his tea to the American market and the name 'Lipton's' became a household name and the United States' most popular tea.

Lipton's became a public company in 1898 and continued to prosper. By the 1920s however, when large companies such as Home & Colonial Stores and Van den Bergh were in competition, the situation changed and in 1927 Van den Bergh acquired 25 per cent of Lipton's shares which bought overall control. Sir Thomas, as he had become in 1897, retired from active control of the company. Within two months he had sold the rest of his interests to the Meadow Dairy Company (controlled by Home & Colonial).

After Lipton, Glasgow's best-known grocery establishments were the big four: A. Massey & Sons, R. & J. Templeton, Galbraith Stores and Andrew Cochrane. The Massey chain began in 1872 when Alexander Massey opened his first provision shop at 166 Crown Street, Gorbals. As his business expanded, to strengthen his retailing activities he bought warehouses and curing houses in Clelland Street. This diversification gave Massey a guaranteed supply of bacon and hams for his shops and the ability to supply other grocers wholesale. Sausage manufacturing was added to the wholesale side of the business.

The façades of all Massey's shops were identical with a red frontage and gilt lettering. Windows had either ham or butter, lard and margarine displays. Massey's catered for the 'breakfast trade'. The shops opened at 7 a.m. to sell ham and eggs to housewives whose husbands started work at 6 a.m. in the shipyards, mills and factories in Glasgow, and who came home for breakfast at 9 a.m.

By the beginning of the 20th century, Massey's was increasingly an integrated provision and grocery merchant and while shops had been opened in Edinburgh, Greenock, Dundee and Paisley, expansion was mostly in Glasgow. During the 1920s trading was difficult; in 1929 The Margarine Union, formed by the amalgamation of two rival Dutch margarine dynasties, Van den Bergh and Jurgens, who consequently amalgamated with Lever to create Unilever, made Massey an excellent offer for its business. Massey accepted and in 1930 became part of Home & Colonial, owned by Jurgens. The shops continued to trade under the Massey name until the 1970s.

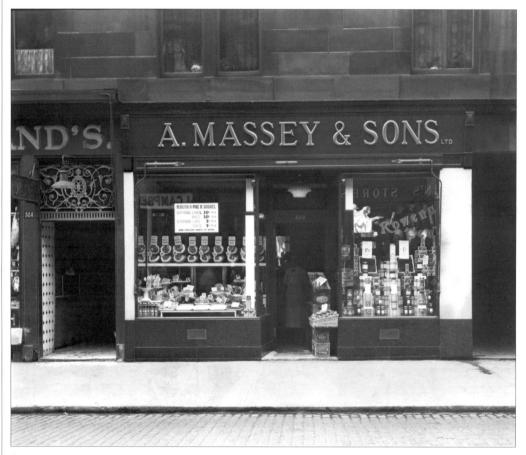

A. Massey & Sons in Victoria Road in 1932. As was usual with Massey, one window is full of hams. A notice states that sausages are reduced, Oxford Links selling for 10d a pound. In the doorway is a box of Fyffe's bananas, a commodity that vanished from shops for the duration of the Second World War. Massey's own brand of tea, Rowena, is advertised.

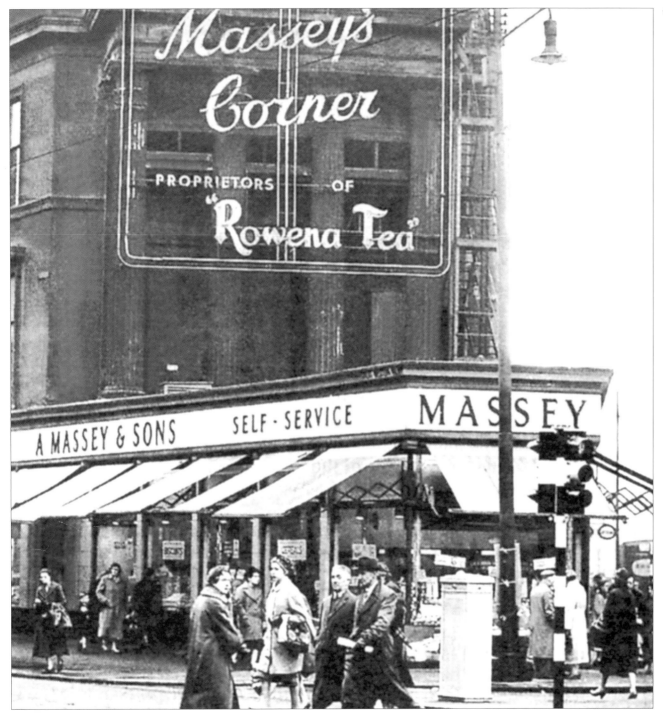

The 'gushet' (triangle of land) at Great Western Road and Maryhill Road was known as Massey's Corner. When this photograph was taken at the beginning of the 1960s, Massey had moved with the times by becoming a self-service shop.

R. & J. Templeton's grocery shop in Norfolk Street (*top right*) in the Gorbals in 1904, where two men who look like senior assistants flank the doorway. A lesser assistant is to the right and a boy is on the left. All are wearing their grocers' white aprons. Teas are advertised, as are chocolates and confectionery, unusual then in a grocery store. Robert Templeton was a countryman from Kilmaurs in Ayrshire who came to Glasgow to make his fortune with his brother John. Robert took a job with a wholesale grocer and his brother went to work in a boot and shoe shop.

Robert opened his first grocery shop in South Wellington Street in the late 1870s and when the number of his shops began to grow his brother John joined him in the business. By 1900, R. & J. Templeton, 'tea merchants and cash grocers', had opened 40 stores mostly in Glasgow. The firm's own-brand teas were blended at their warehouse in Dale Street in Bridgeton. The number of branches grew to 84 and in 1920 the firm was sold to Home & Colonial but continued to trade under the Templeton name until the 1970s.

The William Galbraith store in Paisley Road West in 1934 (*bottom right*) . William Galbraith, the founder of the company, worked for his father in his tiny grocery store in the village of Linwood near Paisley. In 1882 he went to Glasgow to work in a large grocery store. Two years later he returned to Paisley where he opened his own shop in Sandholes Street, trading under the name of Galbraith Stores. By 1900 there were 12 branches in Paisley served from a single warehouse. By 1914 Paisley had 20 branches and Glasgow had 35. All the store fronts carried a uniform black and red decora-

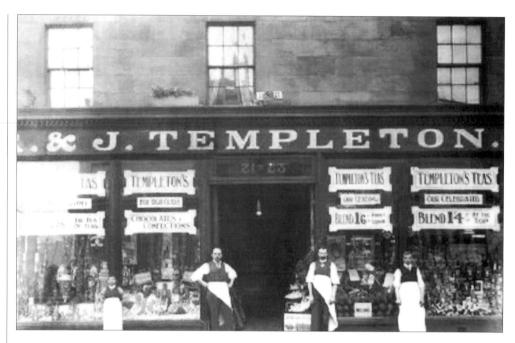

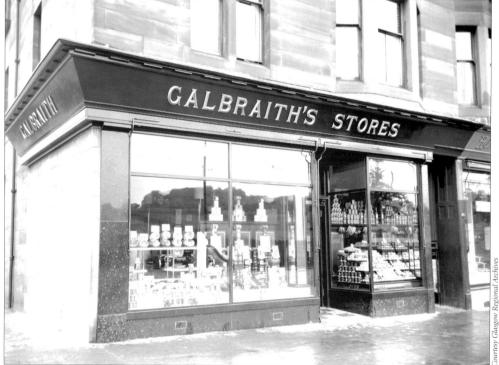

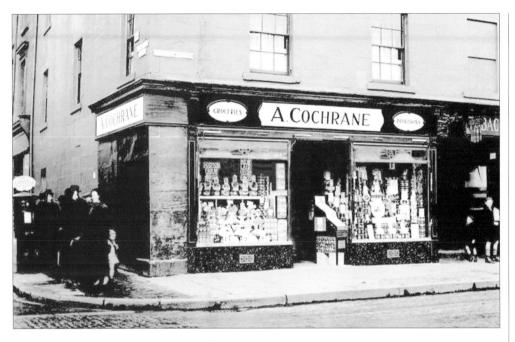

tion. Inside was green tiling with marble shelves for hams. Galbraith sold cheaply for cash. The shops traded as general grocers, carrying a wide variety of goods, not relying on eggs, butter and ham, like Lipton and Massey did to start with. Galbraith had no time for advertising stunts such as those employed by Lipton; he let his low prices speak for themselves. In 1910 Galbraith opened his own bakery in Govan.

In the 1920s, Home & Colonial attempted to buy Galbraith Stores. This failed, as did a further attempt made in 1945 following the death of William Galbraith. Eventually in 1954, the 250 shops, plus the Govan Bakery and the Greenhill Jam Factory, were sold to Home & Colonial.

Andrew Cochrane came to Glasgow from Alyth near Blairgowie (*top left*) where his family had a smallholding. He opened his first shop in South Wellington Street (now Lawmoor Street near Caledonia Road) in 1881 and by 1888 he had shops in Stevenston Street, Gallowgate and King Street. By 1914 he had built up a chain of 100 grocery shops in and around the city. In the late 1920s, The Margarine Union bought the company, which by then had 137 branches. As with A. Massey & Sons and R. & J. Templeton, Andrew Cochrane continued to trade under its own name until the 1970s. This photograph shows the Andrew Cochrane shop at 227 Duke Street in 1938.

This photograph (*bottom left*) shows one of the first supermarkets in Glasgow and while it is definitely known to be in the city, just exactly where is now unknown. The Co-op however, was one of the first to change their shops to supermarkets so it could be one of theirs.

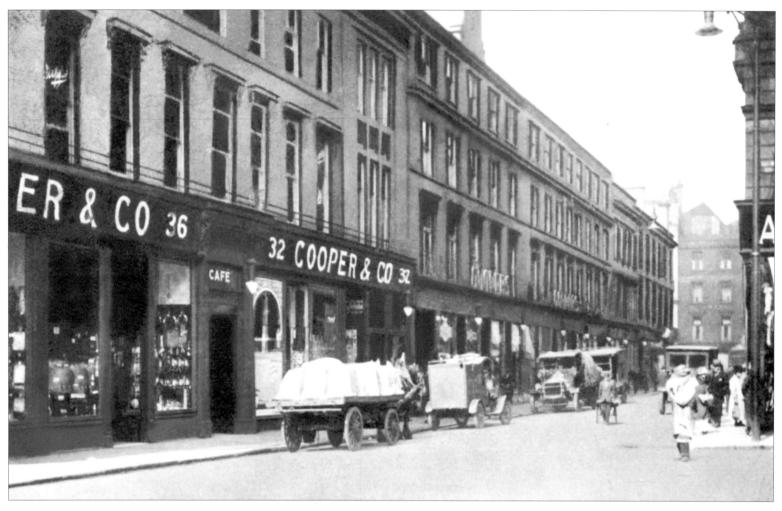

Cooper & Company's shop, warehouse and tea-room in Howard Street in the 1920s. The company was a leading grocery chain in Scotland. The founder of the firm Thomas G. Bishop, opened his first shop in Howard Court in Glasgow in 1871 and soon made a name for himself in the tea business, although nothing like on the scale of Thomas Lipton. He also sold coffee and had big red machines for grinding coffee beans in his shops.

Bishop loved new ideas and his shop in Sauchiehall Street was the first to install electric lights. He also installed a field telegraph to allow direct communication between his three Glasgow stores in Howard Street, Sauchiehall Street and Great Western Road. He was the first to use motor cars for shop deliveries. Erected in 1886, his shop in Great Western Road was famous for its French Renaissance façade and clock tower and according to an 1897 visitors' guide to Glasgow 'few other cities can boast as artistically finished and massive business premises as those of Cooper & Co.' Inside, fluted pillars were decorated with garlands of fruit. The shop closed in the early 1890s and the premises became a pub. In the early 1970s Cooper & Company was taken over by Finefare.

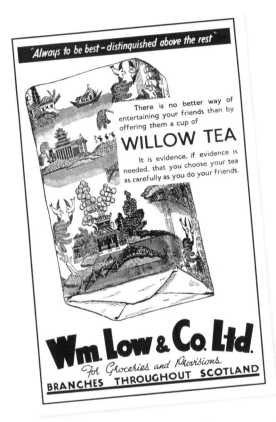

❧ An advertisement for Wm Low's tea in the early 1950s.

"Always to be best - distinguished above the rest"

There is no better way of entertaining your friends than by offering them a cup of

WILLOW TEA

It is evidence, if evidence is needed, that you choose your tea as carefully as you do your friends.

Wm. Low & Co. Ltd.
For Groceries and Provisions
BRANCHES THROUGHOUT SCOTLAND

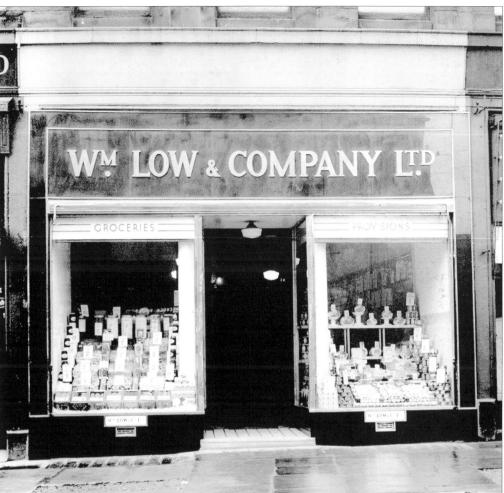

Courtesy Glasgow Regional Archives

A well known grocery name in Glasgow was Wm Low, founded in Dundee. This photograph shows the Cowcaddens shop in 1939. William Low, born in Kirriemuir in 1858, left home at the age of twelve to work in his elder brother James' grocery shop in Dundee. When he was 21 William took over the running of the shop while his brother embarked on a wholesale grocery business. By 1881 William had eight branches in Dundee selling staple foods at affordable prices just as Lipton and Massey had done. Although at first the group was smaller than most of its competitors, eventually there were branches throughout Scotland and North East England. Wm Low almost doubled in size between 1976 and 1984 and became one of the market leaders in Scotland. At one stage it ran a chain of frozen food stores known as Lowfreeze which was sold to Bejam. The company retained its independence until 1989 when it was sold to Tesco who had to compete with a rival bid from J Sainsbury. Fifty-seven of the William Low stores were converted to the Tesco fascia. Prior to this there were only around 17 Tesco stores in Scotland.

Robert Jackson's grocery shop at 11 Harriet Street, Pollokshaws in 1910. As was common at the time the staff are pictured outside the shop in their white aprons, probably because it was too dark to take photographs inside the shop. Cocoa must have been popular as there are adverts in the window for Rowntrees, Rova, an early brand name and Van Houten's. It became popular after the 1888 Glasgow International Exhibition where the company built a sixteenth-century Dutch style Van Houten's Cocoa House in which girls in Dutch national dress served cocoa at 2d a cup. No grocery shop window at the time was devoid of hams and among those Jackson's displayed was Finest Belfast Smoked, Finest Boiled Bacon, and Finest Mild Cured. Also for sale is Milk Maid brand toffee and milk. Stevenson's, Bilsland's and Beattie's Bread are advertised as are Crawford's biscuits. On the top shelf are what look like spirit bottles, indicating that the establishment was an off-licence as well as a grocer.

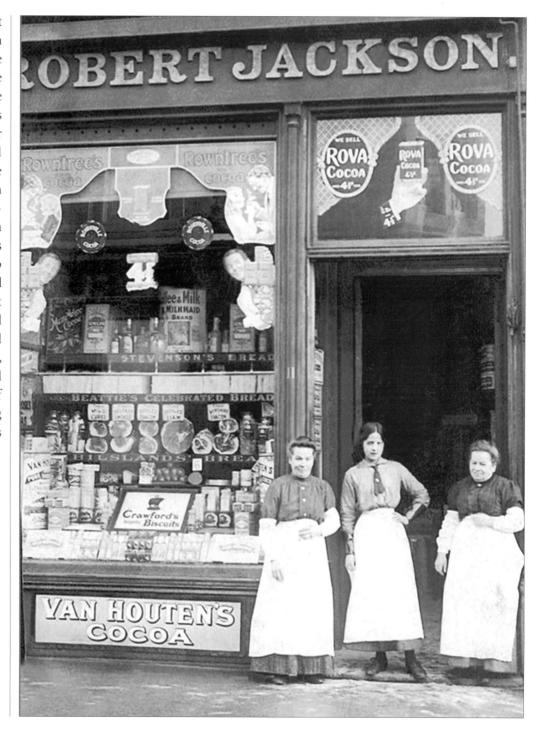

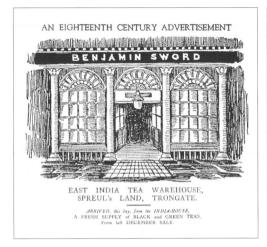

AN EIGHTEENTH CENTURY ADVERTISEMENT

BENJAMIN SWORD

EAST INDIA TEA WAREHOUSE,
SPREUL's LAND, TRONGATE.

*ARRIVED, this day, from the INDIA-HOUSE,
A FRESH SUPPLY of BLACK and GREEN TEAS.
From last DECEMBER SALE.*

✱✲ *Right*. Benjamin Sword's East India Tea Warehouse in Spreull's Land, Trongate was one of the most up-to-date shops in Glasgow at the close of the eighteenth century. Sword was a tea merchant and this woodcut of 1793 gives a good idea of the high style in which he conducted his business. At that time tea was prohibitively expensive for the average working class family; only the wealthy could buy it and even then they were very sparing when using it.

✱✲ *Below*. Dating from 1925 this photograph shows James & George Hunter's provisions shop at the corner of Albion Street and Byres Road. It was an upmarket establishment and judging from the number of staff photographed outside, business must have been brisk to justify employing so many. Established in 1875, the business survived until 1960. It was also an off-licence with its own blend of whisky, Victoria Blend. At the time the photograph was taken Yara-Yara Australian wines were well advertised. The window to the right displays uncovered hams, unacceptable today.

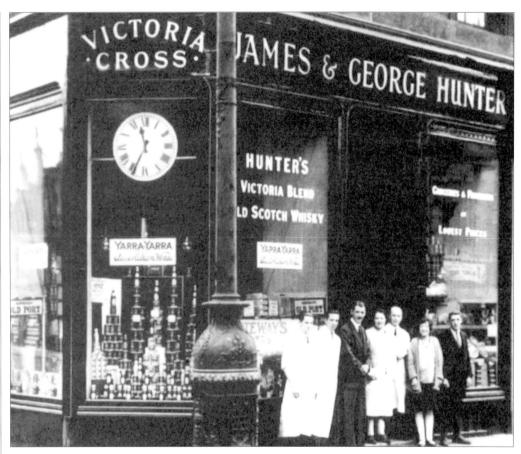

Many consider that the foundations of the global co-operative movement go back to 1769 when the Fenwick Weavers' Society formed a consumer co-operative for the benefit of members. A pioneering example of an organised consumer co-operative society in Scotland was the Govan Victualling Society that had painted over its doors 'established 1777'. It ceased business in 1908.

As more retail societies emerged in Scotland the Scottish Co-operative Wholesale Society (SCWS) was founded in 1868 by forty local societies as a cost-effective way to supply these retailers as a wholesaler. Membership was open only to registered co-operative societies and employees. The Society's first premises were in Madeira Court in the Kingston district. Because manufacturers proved unreliable the society embarked on production with the acquisition of a tailoring business in 1881. Other works followed, and in 1885 a site in Shieldhall (west of Govan) was obtained. A massive complex was built producing a wide range of foods as well as such diverse articles as furniture, clothing, tobacco, paper bags and chemical sundries. It had its own power

station and stables and by 1914 was employing over 4000 people in more than 100 different trades and occupations. The Regent Mills beside Partick Bridge produced 'Lofty Peak' flour. Monumental SCWS headquarters were built at 95 Morrison Street just across the river from the society's original modest premises in Madeira Court. The SCWS was among the leading producers of cigarettes in Britain from the 1930s to the 1950s. One of its brands was Rocky Mount cigarettes made from tobacco harvested in Rocky Mount, North Carolina and processed at Shieldhall.

Although the co-operative system appealed to the working-class shopper, not just because of the good quality products at affordable prices, but because of the dividend or 'divi' as it was known, paid on the quantity of purchases, it provoked a hostile reaction from independent traders who claimed it undermined free competition and private enterprise.

The SCWS acquired a nationwide reputation for producing goods of the highest quality at the keenest prices and became an integral part of daily life for most working-class Scots. It was a major employer, manufacturer and retailer, and provided welfare and banking through the share system.

Although the Co-op stores were among the first to adopt self-service in the 1960s, they were slow to modernise and innovate, resulting in a decline. The end came in 1973 when, following difficulties with the SCWS Bank, the SCWS merged with the CWS which then became primarily involved with retailing.

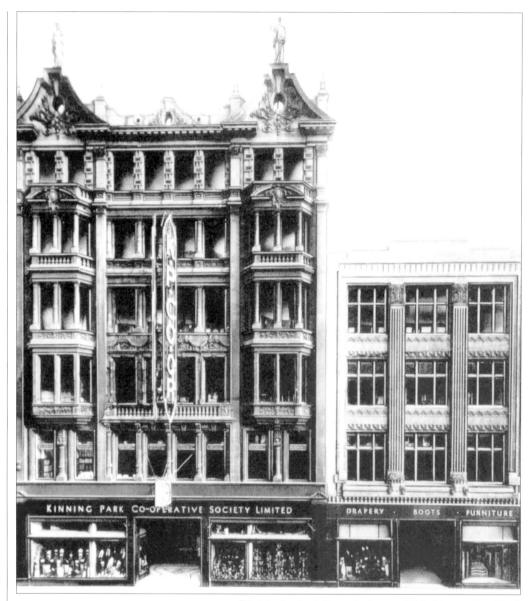

⁂ Kinning Park Co-op Society, established in 1871, flourished until 1952 opening retail and manufacturing premises in Kinning Park and neighbouring districts south of the Clyde. This photograph shows the shop and warehouses at 47-61 Bridge Street designed in 1902 by Bruce and Hay. With the demise of Kinning Park Co-op, Glasgow South Co-op took over the buildings which are among the few in the street to survive the demolitions of the 1970s.

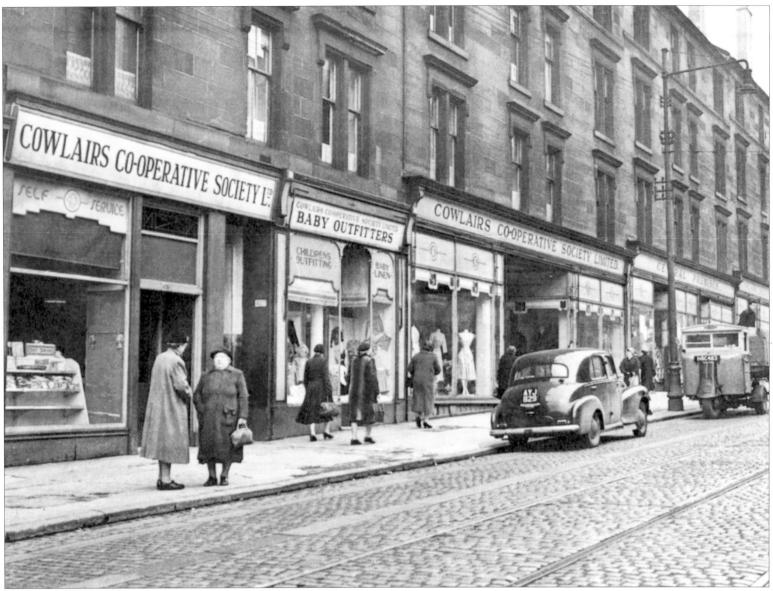

Founded in 1881 by a group of North British Railway employees, the Cowlairs Co-operative Society sought to reduce workers living costs through buying in bulk and sharing profits through the dividend. Although the society became the largest retail organisation in Springburn and the biggest employer it did not survive the massive changes that came about in Springburn as a result of its industrial decline.

This photograph shows the many branches of Cowlairs Co-op in Springburn Road in the 1950s.

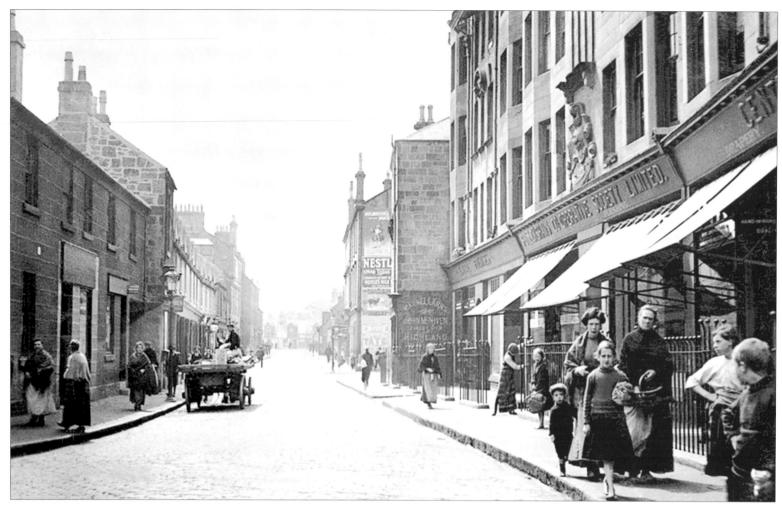

Founded in 1864, Pollokshaws Co-op Society operated from a private house in its early years. Eventually it was able to open a number of branches and in 1904 it built a tenement with shops below and houses above at 72 to 104 Main Street. This photograph, *c.* 1910, shows to the right the building in which the Co-op had six shops – furnishing, dairy, grocery, butchery, drapery and footwear.

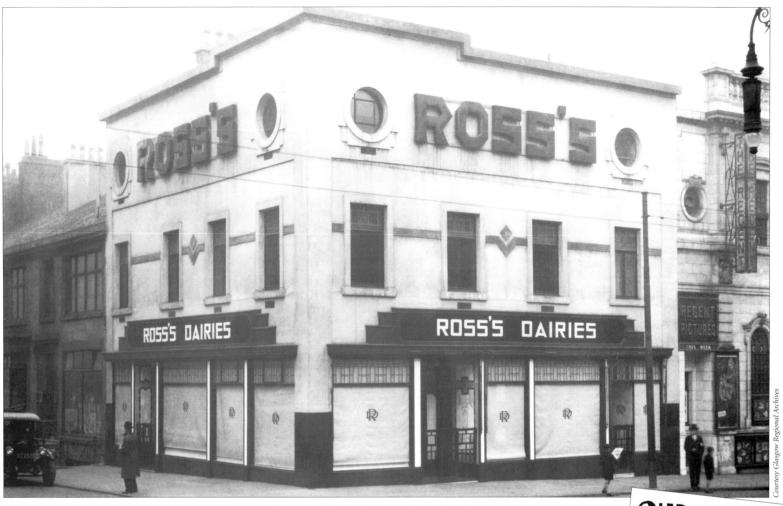

Above. Out of all the dairies in Glasgow, Ross's was the most well-known. This photograph shows the branch at the corner of Renfield Street and Bath Street in the 1930s. In its heyday, the Ross's Dairy empire, consisting of dairy shops, bakeries and milk bars, covered Glasgow and the surrounding district. In the 1930s the company opened what it called 'Electric Bakeries', the premises of which were ultra-clean and modern, with Art Deco styling such as decorative tiles and stained glass panels at the tops of the windows. Even the company's creamery, built in 1938 near the gushet of Crow Road and Clarence Drive, was in Art Deco style. Customers were enticed into the bakeries as all kinds of scones and morning rolls were baked on griddles in the window.

In the 1930s, the company developed a chain of Milk Bars, there being a great boom in milk drinking at the time vigorously promoted by the Scottish Milk Marketing Board. Ross's advertising emphasised that their Tuberculin-tested, pasteurised milk was ideal for infants and for the whole family. The slogan was 'It's Ross's – It's Right.' In 1938, Ross's sponsored one of the milk bars at the Empire Exhibition in Bellahouston Park. For such a progressive firm, as late as the 1950s it relied on traditional horse-drawn milk wagons for making deliveries.

Right. This advertisement of 1940 shows that Ross's promoted a public-spirited wartime message that suggested its war effort was to keep milk supplies flowing.

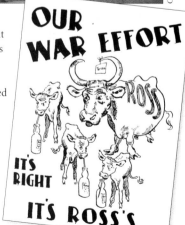

OUR WAR EFFORT

IT'S RIGHT

IT'S ROSS'S

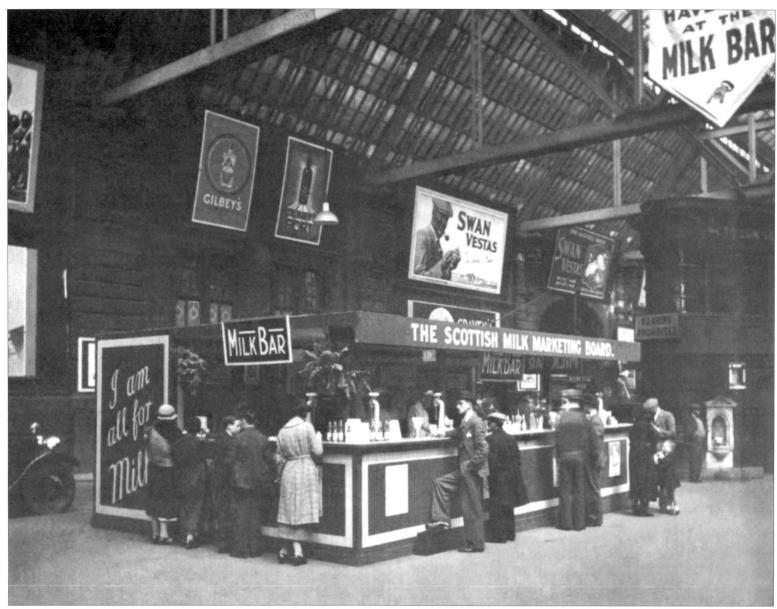

While Ross's was at the forefront of Milk Bars, there were other companies involved in promoting milk and this photograph shows Morton's Milk Bar in Central Station in the 1930s. Across the front of the bar is a sign advertising THE SCOTTISH MILK MARKETING BOARD. The bar was extremely popular with the young as it served American style snacks like waffles, unknown in Glasgow. The customers enjoying their milk around the bar are varied. The lady to the left has a shawl wrapped around her indicating that she had a baby with her. Nearby, are two well-dressed teenagers, (no casual gear then). Beside the boys is a young woman and next to her a very smartly dressed man wearing a soft hat. A couple of the customers sport cloth caps and to the right it looks like Mum and Dad have treated their son who is sipping his milk through a straw. While a poster at the bar states 'I am all for Milk', advertising above the bar is not so healthy – Gilbey's Port and Swan Vestas matches showing a man lighting a pipe.

Although in the dairy trade Ross's was the major force in Glasgow there were countless small dairies in localities all over the city. The following photographs show two.

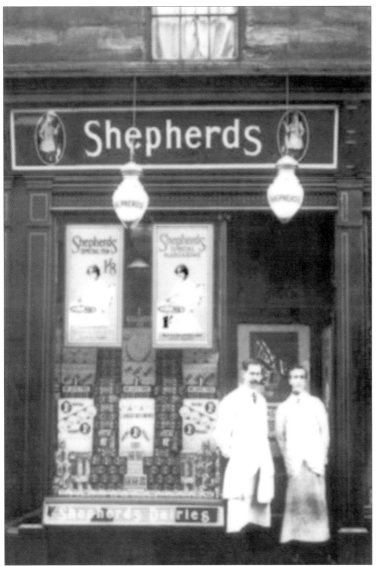

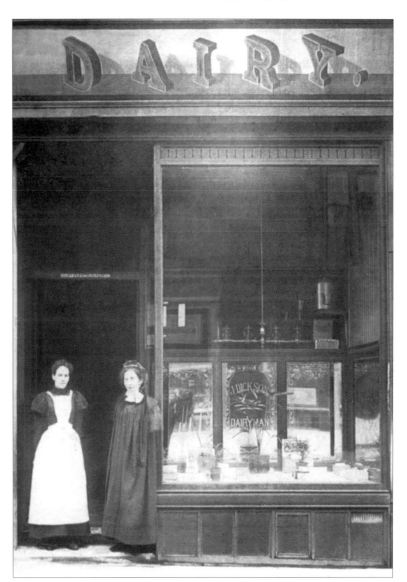

❧ The first is Shepherds Dairies' shop in the Gallowgate shown in 1920. Although it belonged to a dairy company, it was more of a grocery shop as it had its own brand of tea and margarine as advertised in the windows that were filled with tinned goods much like a grocery establishment. The shop was not a backstreet dairy as can be seen from the shop front which was immaculate. It even had light fittings bearing Shepherds' brand name.

❧ The second small dairy is that of J. Dickson at 27 Skirving Street, Shawlands photographed around 1901. Common among all the photographs is that the assistants are photographed outside their establishments.

Bilsland Brothers' shop at 29 Elderslie Street in 1922. This family bakery business was founded in 1872 by William Bilsland. In 1882, by which time his brothers James, John and Alexander had joined the business, a large bakery was built in Hydepark Street where it produced only the finest quality bread, which it supplied to the company shop in Elderslie Street and the retail trade.

The business flourished, and in 1912 it took over the bread business of biscuit manufacturers Gray Dunn & Co. Also that year, appreciating the possibilities of motor transport, the firm purchased a fleet of motor vans to service outlying districts, greatly increasing the range of deliveries. In addition to the trade in and around Glasgow, a large business developed with the Highlands and Islands and with distant country districts where bread was sent by rail or steamer.

Originally, the firm was only concerned with bread manufacture and it was not until 1924 that it added flour, confectionery and cakes to its production, biscuits being added in 1937.

Bilsland became part of Spillers who eventually dissolved the company and sold the smaller bakeries to Mothers Pride. The Hydepark Street factory still stands with the words 'Bilsland's Bakery' prominently displayed on the tower.

The most well-known bakeries and tea-rooms in Glasgow were the City Bakeries, which apart from J. Lyons & Co. was the largest retail baker in Britain.

The business began in 1897 when Robert Urie of Paisley bought the Friendly Baking Company in Clarendon Street, Glasgow, a workers' co-operative bakery formed by industrial workers to ensure that they had cheap and wholesome bread. The bread was delivered round the doors by horse and cart as bakeries then only sold cakes, biscuits and sweetbreads. In 1905 Urie changed the name of the business to the City Bakeries Limited at which time it began to produce cakes and bakery goods. When Robert's son John joined the company, attention was turned to tea-rooms which had become popular in Glasgow and in 1919 he bought the Ca'd'Oro Building on the corner of Union Street and Gordon Street. The Italianate renaissance-style building had three storeys to which Urie added another two. The bakery shop was on the ground floor, the tea-room on the second floor, the restaurant on the third floor and the banqueting halls and ball-rooms on the new fourth and fifth floors. In 1928 Urie bought the long-established tea-room and bakery businesses of Walter Hubbard & Co and Colquhouns of Glasgow. These companies retained their names but were supplied from the Clarendon Street bakery. In 1938 Allied Bakeries bought the City Bakeries which, however, retained its name until it vanished from the high streets in the 1980s.

If the City Bakeries was Glasgow's favourite bakery company, the UCBS was

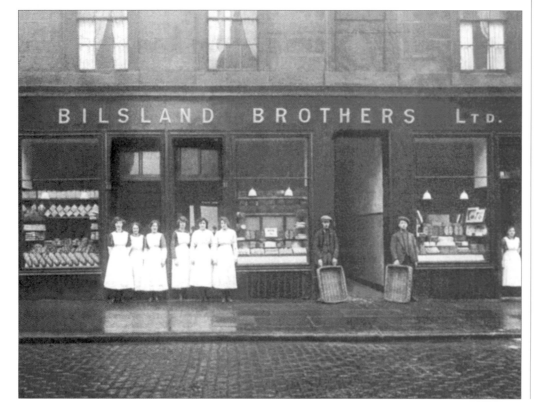

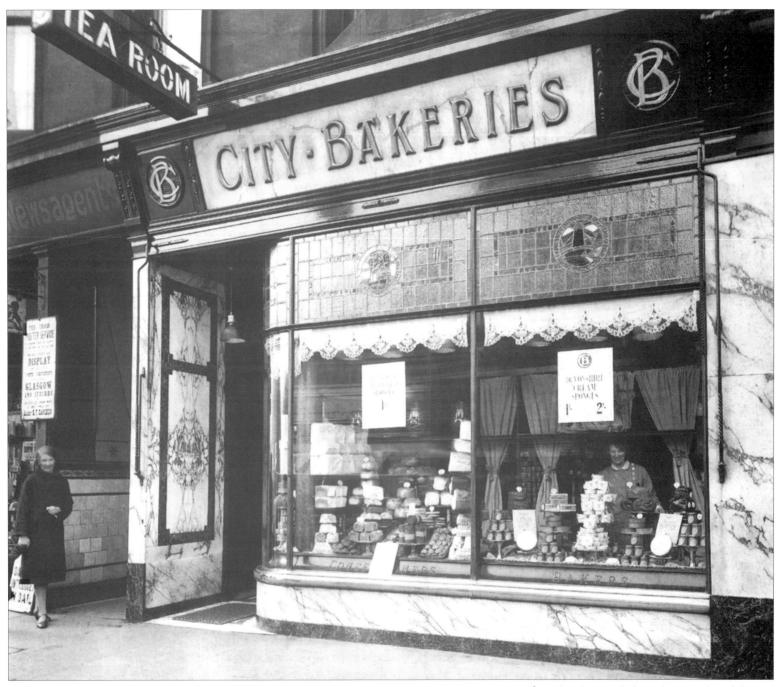

This photograph shows the City Bakeries' shop and tea-room at Parkhead Cross in the 1930s.

not far behind. Countless Glaswegians had the purveying (catering services) for weddings, funerals and family occasions done by one or other of these companies.

The United Co-operative Baking Society Limited was a federation of Co-operative Societies organised to carry on the business of baking and allied industries. It was founded in 1868 by eight societies, none of which had sufficient capital or trade to warrant starting bakeries on their own behalf. The site of the Society's first premises in Coburg Street is covered by part of the former Coliseum Cinema. The famous McNeil Street bakery in Glasgow began in 1887 at which time the federation consisted of 36 societies. Like the City Bakeries, the UCBS began to open tea-rooms, the first in 1893 in Renfield Street. Purveying departments were also opened. Due to dissatisfaction with the service provided by the UCBS, there were calls for the Clydebank society to establish its own bakery and a large biscuit factory was opened in John Knox Street in 1903. The UCBS bakeries vanished when the SCWS merged with the CWS in 1973.

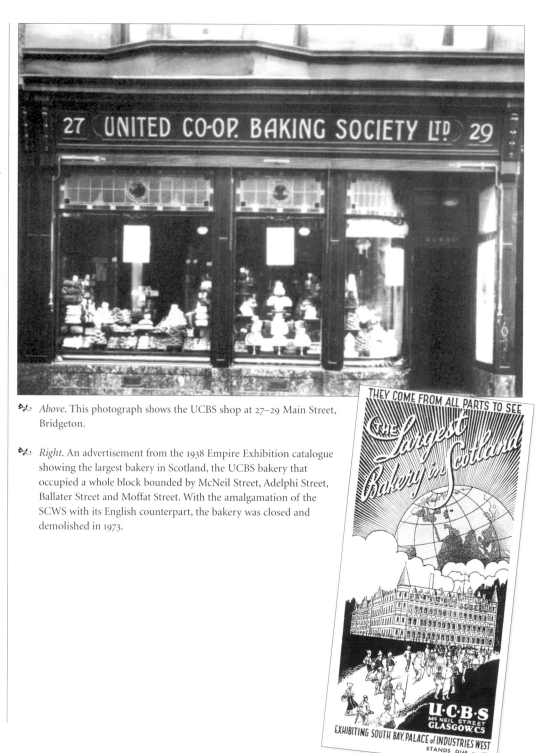

Above. This photograph shows the UCBS shop at 27–29 Main Street, Bridgeton.

Right. An advertisement from the 1938 Empire Exhibition catalogue showing the largest bakery in Scotland, the UCBS bakery that occupied a whole block bounded by McNeil Street, Adelphi Street, Ballater Street and Moffat Street. With the amalgamation of the SCWS with its English counterpart, the bakery was closed and demolished in 1973.

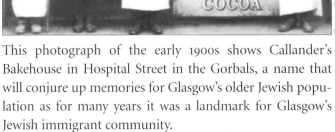

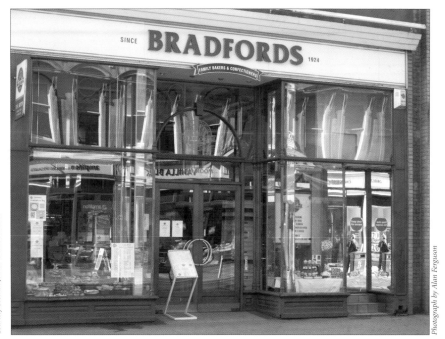

This photograph of the early 1900s shows Callander's Bakehouse in Hospital Street in the Gorbals, a name that will conjure up memories for Glasgow's older Jewish population as for many years it was a landmark for Glasgow's Jewish immigrant community.

Abie Callander left his native town of Lodz in Poland as a teenager. He learned his craft in Hull where he was apprenticed to a master baker. On arrival in Glasgow, he rented a shop and small bakehouse in Hospital Street. Over a period of many years the Callander family, father, mother, sons and daughters, worked together in the bakehouse and shop. In the summer holidays, Alex, the second son, used to deliver bread, groceries, Schmalz herrings, voorsht, etc. all over Glasgow, and to those Jewish families lucky enough to be having a holiday 'doon the watter'. Impossible to think of surviving without basic foodstuffs!

Bradfords shop and tea-room in Sauchiehall Street in 2010. Hugh Bradford, with his sons Hugh and William, founded the company in 1924 in small bakery premises in Niddrie Road on the south side of Glasgow. During the 1930s the business was transferred to Pollokshaws Road where it remained with one large busy shop until 1969 when the premises were sold. The grandson of the founder then decided to continue the family tradition by starting afresh with his wife and three employees in Torrisdale Street. The quality and range of goods was increased with wedding cakes becoming a speciality. In 1982 the company moved to its present site at the Waterfall Bakery and in 1984 it opened its first city centre shop in Cambridge Street, which had a separate tea-room. In 1989 the flagship shop moved to Sauchiehall Street where it has the privilege of being the largest artisan bakers shop in the United Kingdom situated on three floors. It is still a family-owned and operated business.

In 1998 Bradfords Bakers brought back to Glasgow a famous tea-room name that began in 1889 and disappeared in the mid 1950s. That name was Miss Cranston's Tearooms and its namesake in Gordon Street has grown to become an important part of Glasgow culture. It is now renowned throughout the world, with many tourists making a special visit on their travels to Scotland.

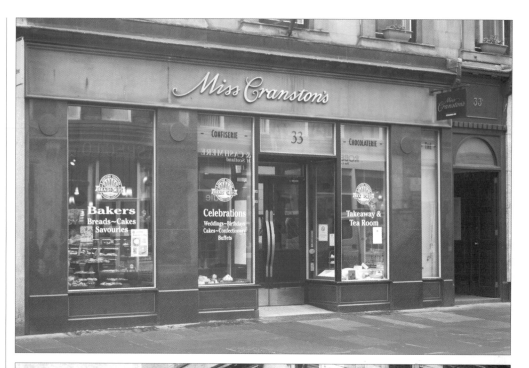

This photograph, *c.* 1950s, shows the building at the east corner of Argyle Street and Queen Street where the world's first tea-room came into being. It was begun by Stuart Cranston, who in 1871 had set up as a retail dealer at 44 St Enoch Square under the designation 'Stuart Cranston & Co., Trained Tea Taster'. He had opted for the retail trade rather than the wholesale, as dealing with the public suited his eager, intense nature. Four years later, well on the way to making Cranston's Teas a household name using the slogan 'There is no TEA like CRANSTON's', he moved to the building in the photograph. To introduce customers to the joys of quality teas, he took to supplying sample cups of new infusions for the ladies who called at his establishment. As this caused some congestion he came up with the idea of setting aside a room furnished with tables and chairs purely for the purpose of tea tasting. After a while, when it dawned on him that the ladies were using the room, not just for tea tasting, but as a meeting place, he had a flash of inspiration. Why not charge them a reasonable price for the pleasure of drinking their cups of tea? The following announcement soon appeared in the press: 'A sample cup of 4/- Kaisow, with sugar and cream for 2d – bread and cakes extra served in the sample room.' No objection to the charge was raised by the ladies who flocked to Cranston's for tea, cakes and a gossip – the 'Tea-room' had arrived. When it became overcrowded Stuart opened another at 46 Queen Street.

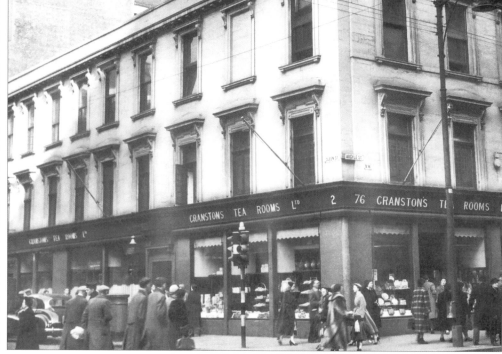

Crollas have been making traditional Italian ice cream in Glasgow for over a hundred years. It began in 1895 when a young Serafino Crolla exchanged the warm sunshine of Southern Italy for the less predictable climes of Scotland and set up his first ice cream shop in Queen Mary Street, Glasgow. His son Giuseppe, opened a second shop in Clydebank and after the First World War opened the Premier Café in Main Street, Bridgeton.

The café is shown in this photograph of the 1920s. Posing outside it are Giuseppe Crolla, his wife and three of their children, Dominic on the left, Lawrence in the middle and Sammy on the right. Giuseppe is the grandfather of Peter Crolla, the company's present Managing Director. The boys are his uncles, his father being born later. The opening of this shop was followed by expansion into the two adjoining premises.

In the 1930s the family sold ice cream around the streets of Glasgow from three-wheeled motor cycles fitted with a hood over the front wheels. By the 1950s Crollas' delicious traditional ice cream had become so much sought after that a factory had been opened and 30 motorised vans were selling the ice cream around the streets.

Today, the company still supplies ice cream vans, but has expanded to supplying shops, cafés, wholesalers, restaurants and hotels using its fleet of refrigerated vehicles.

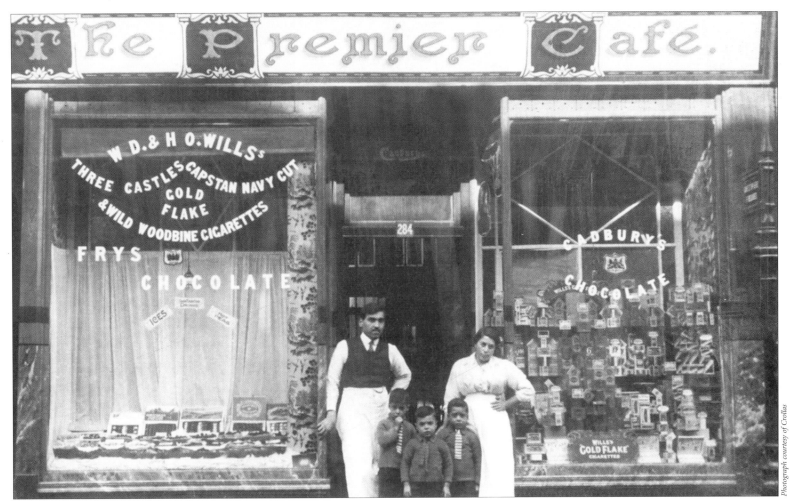

Photograph courtesy of Crollas

There has been a Coia's Café in Dennistoun since 1928. Originally it was at 570 Duke Street, which was demolished during road-widening at the end of the 1980s. Today, it is at 473 Duke Street. The original café was owned by Carmine and Amalia Coia and customers came from all over the East End and beyond to sample Amalia's legendary home-made ice cream. Carmine and Amalia had both come from southern Italy to Glasgow at the turn of the twentieth century and had met and married there.

Amalia's son Nicky and his wife Ena took over the café in the 1950s and added to the business by introducing high-class confectionery and a larger food menu. In those days cafés were open from 9 a.m. to 11 p.m. every day. One customer was gangster, Arthur Thomson, who came in to buy his Sullivan and Powell cigars, the only kind he liked.

Nicky handed the café over to his son Alfredo, who along with his wife Antonia, are the third generation of the family to run the business, now a deli and licensed restaurant. Ice cream is still made to Amalia's recipe, but new flavours have been introduced, ranging from mango to Irn-Bru. Today, people queue to get seats in the restaurant where they can chose from a menu which includes fare such as polenta and chicken and mozzarella baguettes – a change from a plate of hot peas and vinegar as in the old days.

❧ *Right.* Coia's attractive café today, a landmark with its eye-catching bright blue awnings.
All photographs are courtesy of Coia.

❧ *Left.* This photograph shows the old café's hand-crafted booth seating, made by Carmine, a cabinetmaker to trade.

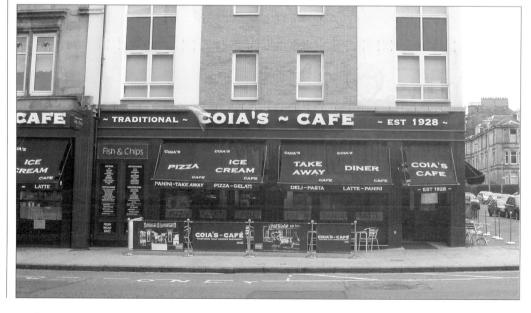

Malcolm Campbell fruit and vegetable shops were seen on high streets all over Scotland. The founder, Malcolm Campbell, born in Kilwinning in 1848, began work in 1864 for greengrocer Mark Walker who had a small shop in Buchanan Street. When Walker retired in 1878 Campbell bought the business, which had transferred to the corner of Gordon Street and West Nile Street. At the time the shop sold mostly vegetables as the main fruits available – in season only – were apples and pears. Strawberries could be had but were not greatly sought after, and the importation of any fruit and vegetables from abroad was unheard of. Things changed when the development of refrigeration in the 1880s made this possible, enabling Campbell to expand his produce range, year by year, and also to open new shops. The tomato for instance, was only used to add flavour to special dishes concocted for a nearby club, but one day a customer purchased one and ate it raw while in the shop, giving it a new use. Campbell also had the distinction of bringing a new kind of fruit to Glasgow. He had a tree heavily laden with this crop brought to the Gordon Street shop for display in one of the windows around which masses of people thronged to gaze in wonderment at this new fruit with a strange name – the banana.

When Malcolm Campbell introduced flowers he had large nurseries built so that flowers and plants could be readily to hand. A Floral Warehouse was opened in St Vincent Street and Malcolm Campbell supplied floral arrangements for most of the city's prestigious and civic occasions. An association with railway stations began in 1904 with the opening of a fruit and confectionery kiosk at St Enoch Station. Eventually there were 60 kiosks stretching from Stonehaven to Crewe. When Sir Malcolm Campbell (he was knighted in 1922) died in 1935, his obituary described him as the man who introduced bananas and tomatoes to Scotland.

In 1938 it was decided that the Gordon Street shop was out of date and a new shop was bought in Union Street beside Central Station, thus ending, after 60 years, a link with the company's beginnings.

Until the sale of its retail business in 2000, Malcolm Campbell was Scotland's largest independent retailer.

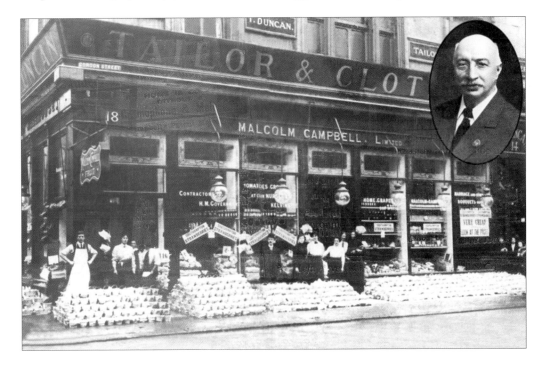

This photograph shows the first Malcolm Campbell shop at the corner of Gordon Street and West Nile Street in 1911, on a day when 3½ tons of strawberries had arrived, a record in its time. The photograph shows staff lined up outside the shop with baskets of Southampton strawberries piled in front of them. The windows advertise tomatoes grown at the company's nurseries in Kelvinside. They also advertise 'marriage' and other bouquets made up by the company's own lady artists. Inset is Sir Malcolm Campbell.

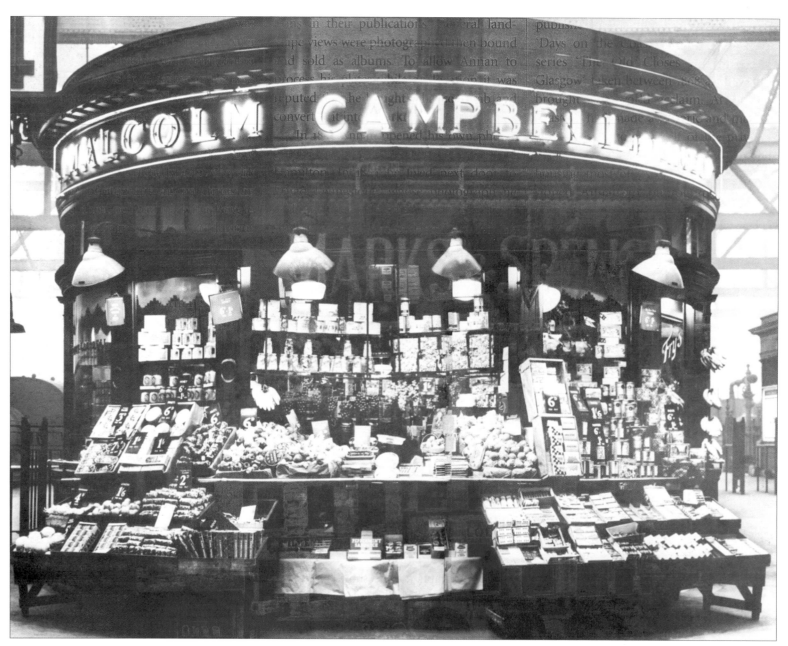

The fruit and confectionery kiosk in Central Station just before the Second World War. Bunches of grapes and bananas hang on display amid boxes and packets of chocolates and sweets. The kiosk was so crowded that it was difficult to see the salespeople through the piles of produce in front of them. With individually polished red and green apples, oranges, plums, lemons, grapefruit and melons, the effect was one of splendid colouring in sharp contrast to the surroundings.

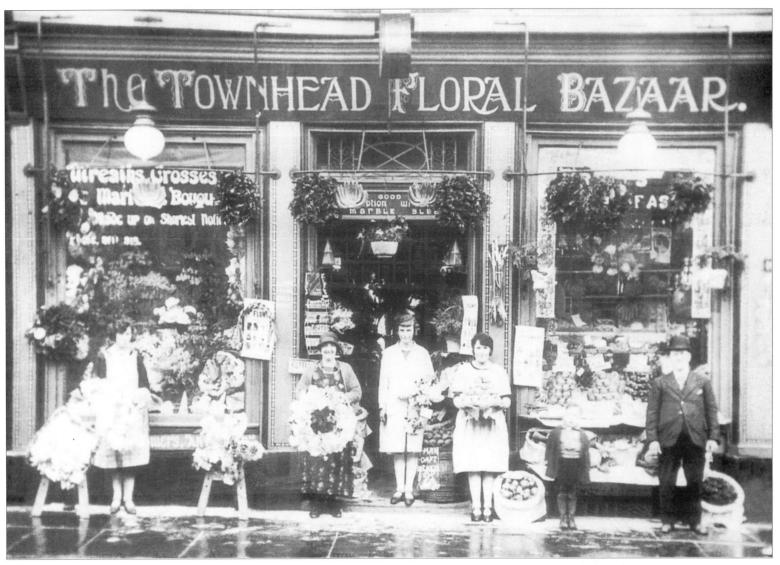

This photograph, *c.* 1920s, shows The Townhead Floral Bazaar belonging to Mrs Agnes Brogan who is posing with her family and staff outside the shop in Castle Street. The shop also sold fruit and vegetables, 'mandaft' potatoes being advertised at 2½d per quarter-stone on the barrel at the foot of the doorway. Mrs Brogan holds a grand wreath and other floral tributes are displayed on stands. According to the advertising on the window, wreaths, crosses and marriage bouquets could be made up 'on shortest notice'. Marble slabs, and flower containers with the words 'Sadly Missed' or 'Deepest Sympathy' printed on them could be ordered.

Of all the sweet shops in Glasgow the most famous name is R.S. McColl. The photograph (*opposite*) *c.* 1960 shows the branch at the corner of Renfield Street and Sauchiehall Street, sandwiched between Renfield Street church and Carswell the gent's outfitter. British Home Stores now occupies the whole site.

The R.S. McColl business began in 1901 when Robert McColl and his brother Tom opened a small sweet shop in Albert Drive specialising in handmade toffee and chocolates, a childhood hobby of both boys. The reason the company was named after Robert Smyth McColl and not his brother Tom, was that Robert was a football hero. He joined Queen's Park at 17 years of age and later played for Newcastle United and Rangers before rejoining Queen's Park. McColl, acknowledged as the 'king' of the centre-forwards was capped 15 times for Scotland, the highlight being a hat-trick in the 4–1 victory over England in 1900. Later he affectionately became known as 'Sweetie Bob'.

Scotland's notorious sweet tooth, coupled with the company's reputation for quality products, brought success and expansion and in 1916 the brothers opened a factory in North Woodside Road to supply the company's 30 branches. Ninety percent of the factory's employees were female. While toffee and tablet were still considered the company's 'specialities', it began manufacturing chocolates, boilings, fondants, jellies and assortments of all kinds.

During the First World War Tom ran the business on his own, Robert having joined up as a private in the RASC, coming out a sergeant-major.

In 1925 the brothers formed a limited company, Robert becoming Chairman and Managing Director, Tom, Joint Managing Director. The next year, that of the General Strike, profits fell. They picked up in 1928–29 but the Depression years were around the corner. To the unemployed, sweets were a luxury they could no longer afford and 1932–33 brought further falls in revenue. In 1933 the brothers sold a controlling interest in their company to the Cadbury Group, retaining their positions, albeit as salaried staff. Being part of a large group enabled the company to open branches in England and to diversify into selling ice cream and cigarettes. Many of the branches were strategically situated next door to cinemas and theatres. By 1935 the firm employed over 800 people in 180 branches.

The brothers retired in 1946 but the name lives on although the shops are now newsagents.

Left. A sweet advertisement *c.* 1950s for R.S. McColl.

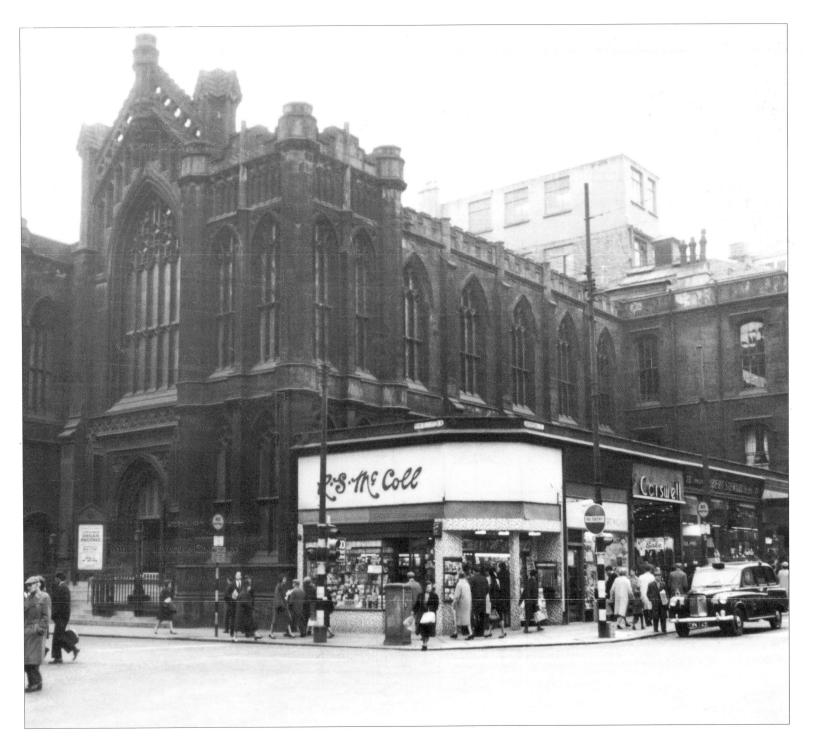

In competition with R.S. McColl was Birrell, which also started life in Glasgow, in 1901, in a modest way and quickly developed into a firm producing on a large scale. Birrell was begun by John Birrell who owned a number of grocery shops. His change of direction came when he began the manufacture of chocolate in one of his shops in Partick.

While Birrell built up a reputation for good quality sweets of a wide variety such as boilings, fondants and jellies, it was particularly associated with fine chocolate manufactured at its 'Milady' works in Anniesland. This reputation may have arisen because the company was unique among Scottish confectionery firms in starting the chocolate-making process from the cocoa bean itself instead of previously prepared chocolate.

An obvious advantage for both R.S. McColl and Birrell was that they had their own retail outlets, allowing them rapidly to adjust their factory production to the vagaries of consumer demand, as reflected in branch sales. When John Birrell died in 1938, there were over 180 branches and other new shops were in various stages of construction. Birrell's shop windows were always attractive. Trays of sweets were widely spaced and arranged in pyramid and circular form. Displays included flower baskets and ribbon bows and price tickets could be easily seen.

In the 1950s Birrell was bought by Mayfair Products and unlike R.S. McColl whose name continues, Birrell's no longer does.

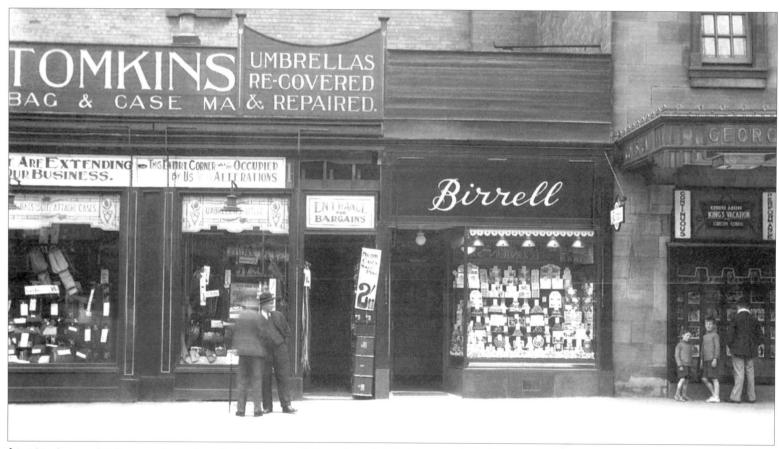

This photograph, taken around 1935, shows the Birrell shop in Eglinton Street. It is sited conveniently beside the Coliseum Cinema which is showing *The King's Vacation* starring George Arliss.

Glasgow's oldest sweet shop is Glickman's at 157 London Road on the fringe of the Barras market. Isaac Glickman, who emigrated from Eastern Europe to Glasgow at the end of the nineteenth century, began it in 1903. Among his handmade sweets were raspberry creams, Turkish delight, mint creams, toffee bonbons, dolly mixtures and 'Soor Plooms', an all-time Glasgow favourite. While he soon had a name for selling quality confectionery, he became renowned for his 'Glickman's Famous Cough Tablet', its powers supposedly legendary for easing colds. During the Second World War, as it was one of the few treats not rationed, Glaswegians queued in droves to buy it. Unfortunately, it cannot be manufactured today as it probably contained chloroform, most nineteenth and early twentieth century cough sweets being laced with it. No wonder they worked.

By the 1930s Isaac had opened two more shops – at Dalmarnock Road, Bridgeton and Garscube Road, Cowcaddens. He liked to confuse his friends as his shops' fascia boards stated 'Established 1910', the reason being that prior to that he had rented the premises and by 1910 he finally owned them. The shops in Bridgeton and Cowcaddens were redevelopment victims in the 1960s.

Today, continuing the family tradition, Isaac's granddaughter Irene Birkett and her daughter Julie run the business. They found Isaac's recipe books in an old diary, and working out, with difficulty, his hieroglyphs, have managed to produce authentic recre-

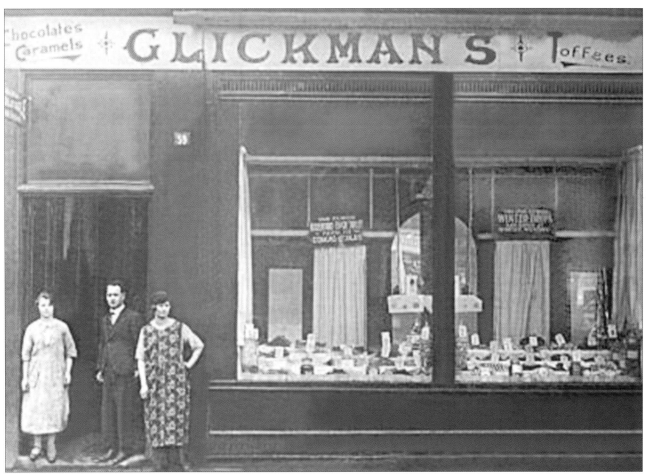

This, unfortunately poor quality photograph, shows Glickman's in London Road in the late 1920s or early 1930s. Isaac Glickman, who established the business, is the man in the middle of the group posing outside the shop. *Courtesy Glickman's*

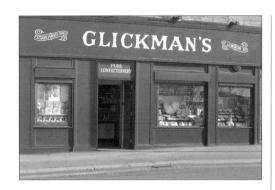

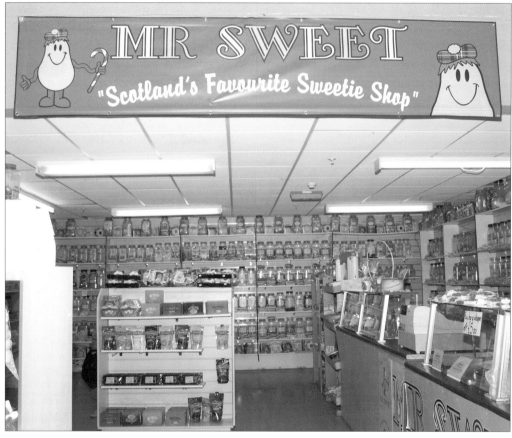

❧ *Above*. Glickman's photographed in 2010.
Photograph by Jim Barker

❧ *Right*. Mr Sweet in Parkhead Forge Market.
Photograph by Jim Barker

ations of his mouth-watering sweets. They make them every week, hand-stirring the mixtures in a big copper pot to retain the full flavour and give them a rich texture. The sweets are then stored in traditional glass jars because it keeps them fresh and customers prefer to see what they are getting. Soor Plooms still reign supreme as Glickman's top seller.

Mr Sweet is one of a new breed of sweet shops that have opened recently. This Aladdin's cave sweet business was started in August 2008 by Jim Smith who proclaims to have the 'biggest sweetie shop in Scotland'.

There are two shops under the Mr Sweet name, one in Parkhead Forge Market and one in the old Kings Oddfellow factory in Stewart Street, Wishaw, which Jim bought. He had been working in the jewellery trade and, wanting a change, chose the world of confectionery. Before setting up his business he travelled the country finding out what grannies' favourite sweets were. He also sought out 100-year-old confectionery firms and bought box after box of sweets whose names take people back to their childhood.

Shelves groan under the weight of jars of old favourites: Fruit Buds, Rhubarb Rock,

Pineapple Cubes, Pear Drops, Cola Bottles and Frying Pan Lollies. Oddfellows, the clove-flavoured sweets, which once went to every corner of the Victorian Empire are also on sale. The sweet was made in Wishaw from 1883 to the early 1990s when the family who owned the business sold it, realising, according to rumour, £500,000 for the recipe. Mr Sweet's biggest sellers are Soor Plooms and Chelsea Whoppers, which have a picture of a Chelsea Pensioner emblazoned on the box.

PART 2
Non-Food Shops

Top. This photograph, possibly taken around 1890, shows Simon Michaelson's general warehouse in the Gorbals whose advertising claimed that the establishment sold everything more cheaply than similar shops in the city. One window shows jewellery, the other clothing. *Courtesy Scottish Jewish Centre Archives*

Below. A. Links' fancy linen shop in Main Street, Gorbals in 1907. The lettering on the window to the left is in Yiddish. On the window to the right the wording is repeated in English. In the Gorbals of 1901 Yiddish appears to have been the main language of the Jewish community. There were posters and hoardings in Yiddish, Yiddish lettering on shops, and for Jewish names, Jewish butchers, Jewish bakers with Jewish bread and Jewish grocers with barrels of herring in the doorway. *Courtesy Scottish Jewish Centre Archives*

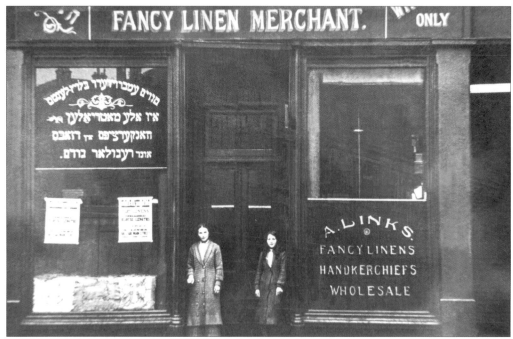

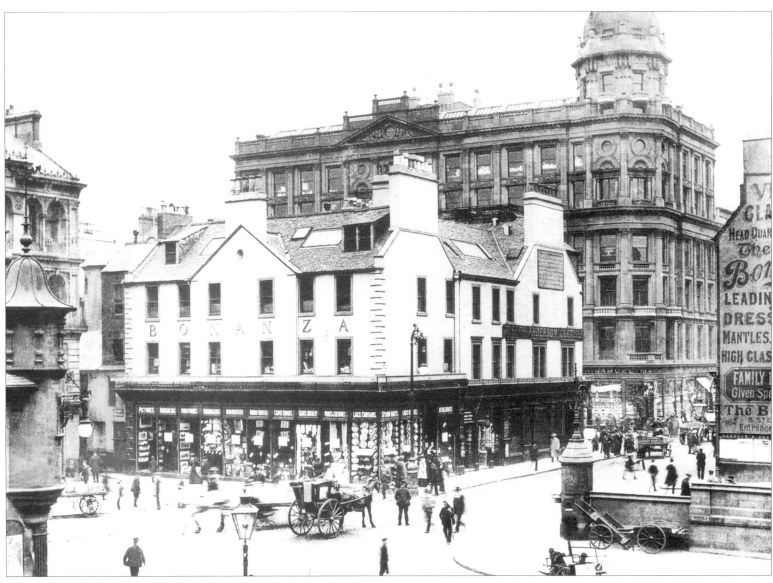

The Bonanza Warehouse in Argyle Street and St Enoch Square, photographed c. 1900. The building was formerly His Lordship's Larder, a celebrated Glasgow hostelry. As the name suggests, The Bonanza was what we would call today a discount warehouse. It opened around 1884 and according to an advertisement at that time, among the goods ladies could buy were Millinery, Underclothing, Corsets, Furs, Lace and Ribbon.

There was a Misses' & Children's Costume Saloon and a New Babies' Outfit Department. Men were not forgotten as there was a Satin and Felt Hat Hall as well as a Glove, Scarf and Umbrella Department. Although patrons were assured of a saving of 25 per cent on all their purchases, Bonanza stated that 'good quality is never sacrificed to lowness of price'.

The photograph is evocative of the 1900s with gas street lamps, push carts and a horse and carriage. As the Bonanza windows are crammed with what looks like boater hats, it must have been summer when the photograph was taken. To the right in the view is H. Samuel's jewellery shop at the corner of Argyle Street and Buchanan Street. Just making it into the photograph on the far left is a corner of the Jacobean style subway ticket office designed by James Miller in 1896, the year the subway opened.

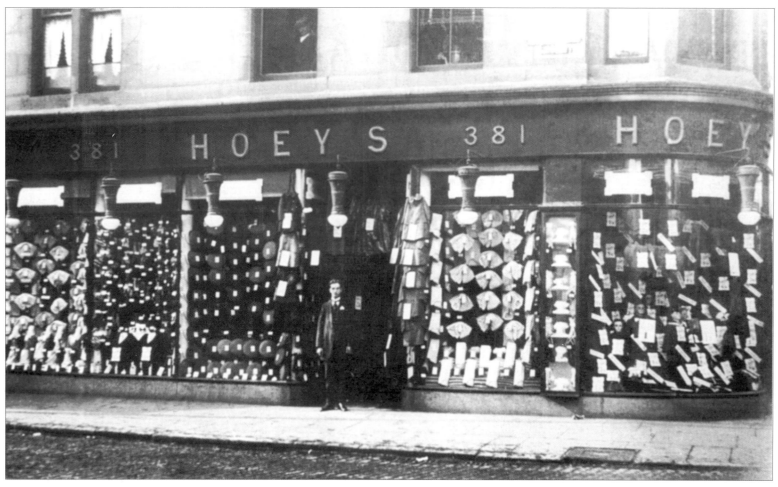

An old established business was D.M. Hoey, founded in 1898 by Donald Hoey. This photograph, dated around 1900, shows the Springburn branch that started as a small two-windowed shop with two of a staff and expanded into an emporium with 36 windows and a staff of 60. The shop was an institution and locals said that there was no need to go into town for any household requirements as 'Hoey's would have it whether it be clothing, furniture, china or carpets.' Prices had to be competitive as its rival was Cowlairs Co-op with its 'divi'. Later there were branches in Dumbarton Road, Argyle Street and Victoria Road plus headquarters in St George's Cross. Outside the city, shops were opened in Cumber-nauld, Kilmarnock and Saltcoats. Hoey's was especially popular around back-to-school time when families flocked to buy school uniforms in which it specialised. In the 1920s, the branch at St George's Cross advertised Hillhead School boys blazers with a silk badge on the pocket from 25s. A regulation cap was 3s 6d.

Like many independent retailers in Glasgow, Hoey's is no more. The last remaining shop, the one in Victoria Road, closed in 2004.

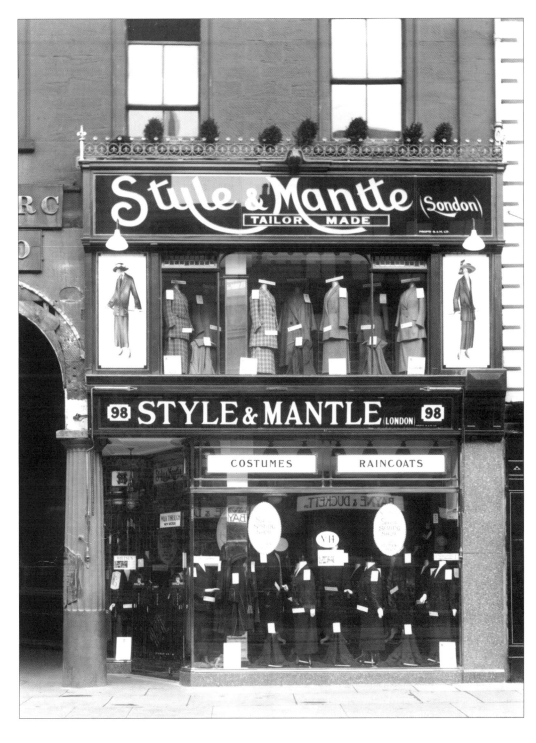

❧ *Left*. This photograph of the 1920s shows Style and Mantle, a stylish dress shop that occupied the east side of the Argyle Street entrance to the Argyll Arcade. From 1921 to 1923 the shop conducted a running battle with the Arcade Management Committee over its plan to remove the stonework between the two first floor windows to allow the insertion of a large showcase window, to which the committee objected. When the case was heard at the Dean of Guild Court, as the photograph shows, Style and Mantle won. Later Style and Mantle became part of the Grafton Group.

❧ *Below*. An advertisement *c*. 1926, for Morrison's shop at South Portland Street stating that only in Morrison's could authentic Paris models such as Patou and Molyneux fashion labels be found. Mrs Edith Morrison, who came to Glasgow from Estonia, started the business in the early 1920s. Like Style and Mantle, Morrison's became part of the Grafton Group.

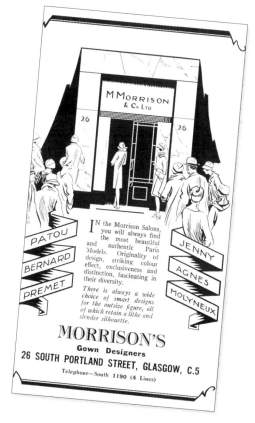

One of Glasgow's most elitist shops was R.W. Forsyth where the well-heeled went to buy wedding outfits, business suits and uniforms for fee-paying schools. The business was begun in 1872 by R.W. Forsyth who set up as a hosier, glover and shirtmaker at 5–7 Renfield Street. Within a year Forsyth had leased two further properties in the street and had begun to sell clothing.

The business prospered and Forsyth gradually acquired all the properties around his store, replacing them with a six-storey building on the corner of Renfield Street and Gordon Street. The new store had every modern convenience, electric lighting and heating supplied by hot water pipes. In 1907 a branch opened in Edinburgh at the corner of Princes Street and St Andrew Street. There was also a smaller Glasgow branch in Jamaica Street and later a branch in London's Regent Street.

When the Edinburgh branch opened, the firm became the official robe maker to the Moderator of the General Assembly of the Church of Scotland. It also supplied academic and ceremonial gowns for university members and dignitaries. In addition, it was the official keeper of the robes of the Order of the Knights of the Thistle.

An example of Forsyth's elitism is demonstrated by its catalogue of boys' clothing and outfitting called 'Men in the Making', issued around 1930. The introduction assured customers that: 'The boy with a 'Forsyth' outfit knows that it is correct – beyond criticism'. It finished by saying that: 'When a boy emerges from parental control of his wardrobe, to the dignity of selecting his own tailor, Forsyth's is still at his service'.

R.W. Forsyth continued to take a close interest in the business into his old age and it remained in the family after his death. When one of the family members, the reclusive Robert Forsyth, died in 1978, he left £2.5 million worth of shares in the business to the Free Presbyterian Church. He had never attended a service, had never taken a part in the running of the business and rarely ventured out. One of the stipulations of the bequest was that no woman smoker should benefit from it.

By the time that Robert Forsyth had bequeathed his shares to the church, sales were declining and overheads were rising. In 1983 the Renfield Street store closed and the firm moved to premises in the Tréron department store in Sauchiehall Street which was destroyed by fire in 1985. The only sign left of R.W. Forsyth in Glasgow is the name that can still be seen carved in the stone above the windows of the former Renfield Street store.

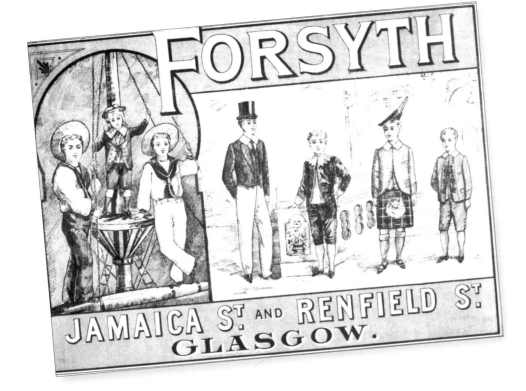

Left. Advertisement *c.* 1890 for Forsyth's boys' clothing – Little Lord Fauntleroy outfits, kilted outfits, top-hatted Eton outfits and sailor outfits (as worn by the Royal Princes). I don't think the poor would have envied the well-to-do boys who would have worn the clothing. It must have been restricting in the extreme.

Opposite. R W Forsyth's building on the corner of Renfield Street and Gordon Street.

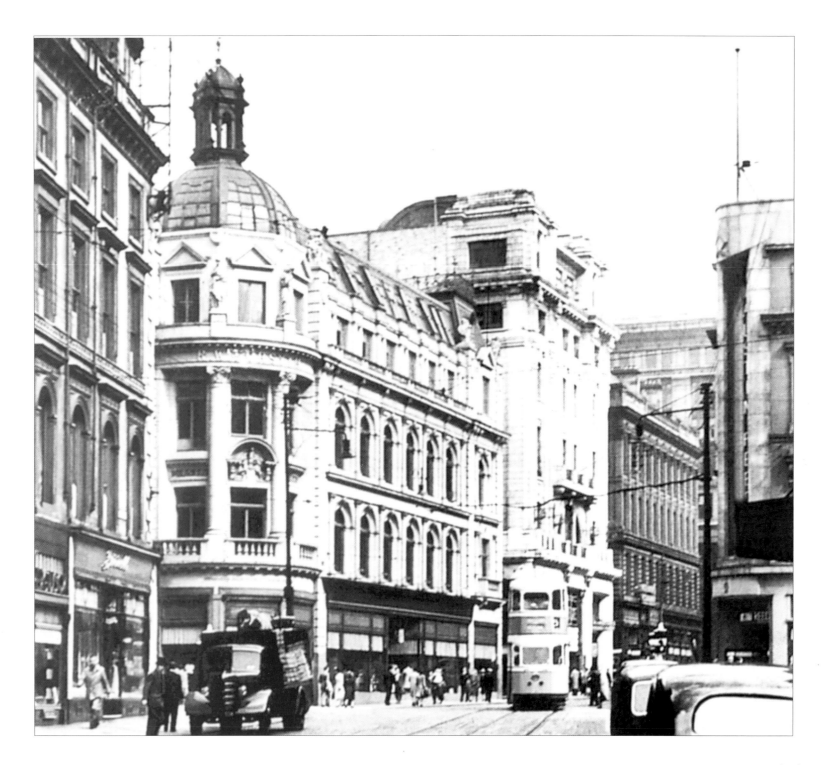

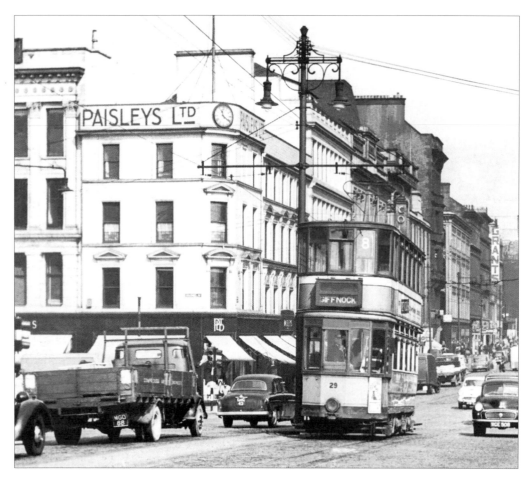

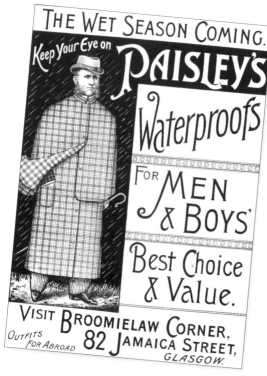

❧ *Above*. Advertisement of 1891 for Paisley's waterproofs for men and boys. Obviously for the well-to-do, judging by the outfit the gentleman is wearing.

This photograph (*above*) shows the upmarket tailors and outfitters, Paisleys Limited, at the corner of the Broomielaw and Jamaica Street in 1958. The company, established in the 1880s, specialised in uniforms and it was where generations of youngsters got their school uniforms and where tradesmen and shop workers got their overalls. As it was a Royal Navy outfitter, it was also where mariners got their shore and seagoing kit. And it was an army issue supplier; during the First World War it was advertising khaki drill regulation jackets and trousers along with patrol jackets and trousers. As it did a large trade in supplying clothing for those going abroad, it was claimed that Paisleys outfits were worn in every corner of the Empire.

On the tailoring side, as well as concentrating on high quality gents' and boys' clothing, it specialised in Highland Dress outfits, and for those who wanted to shop in the comfort of their own home for such items they could do so from the illustrated Highland Dress catalogue.

Later, Paisleys widened its range by offering a large selection of ladies' and gents' clothes for work and play in all climates. There was rainwear, sportswear, beachwear, knitwear, suits, shirts and ties. The sports department stocked everything from tennis racquets and balls to skis and parkas. There was even a toy department.

At the beginning of the 1980s Hugh Fraser acquired Paisleys and renamed it 'Sir Hugh'. Unfortunately, the venture failed within six months as that part of the city centre was no longer popular.

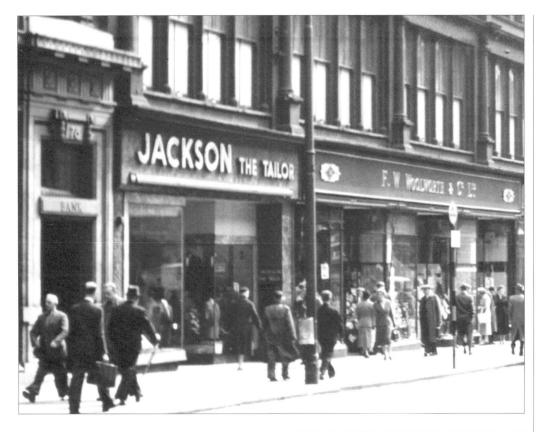

Jackson the Tailor's shop in Union Street in 1957. Jackson was one of Tyneside's most successful businesses in the 1960s and 70s. It was founded by Moses Jacobson, a Lithuanian Jew who came to the North East via the USA. He had opened his first shop in Clayton Street, Newcastle, on the basis of deciding that making and selling a 30s (£1.50p) suit could be a money-spinner. His motto was 'small profits – quick returns'. His business thrived and by the 1960s Jackson The Tailor was one of the most famous menswear brands with, at its peak, more than 500 shops across the length and breadth of the UK. It was seen as the place to go for a suit for special occasions, such as weddings, dances and job interviews. It took two or three fittings for each suit, but if one was needed for a funeral, it could be prepared within a few days. The company had the reputation for providing the most up-to-date fashions. No self-respecting teddy-boy would be seen without his Jackson drape suit or a mod without his Jackson suit. The company was even mentioned in the script for the TV show *The Likely Lads*. Despite its high profile, the firm folded in 1978.

The Jackson name has made a comeback in Glasgow. In 2009 Benny Hamish purchased the right to it and brought it back with the opening of a store in the St Enoch Centre, which he hopes will be a launch pad to opening up to 50 stores over five years.

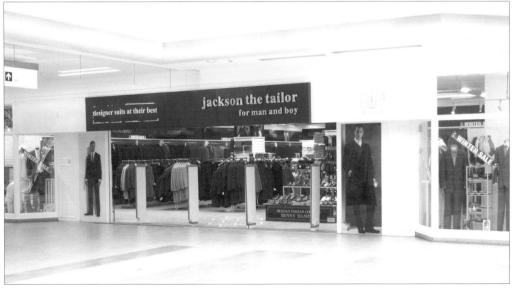

Left. Jackson the Tailor in the St Enoch Centre, a famous name revived.
Photograph by Alan Ferguson

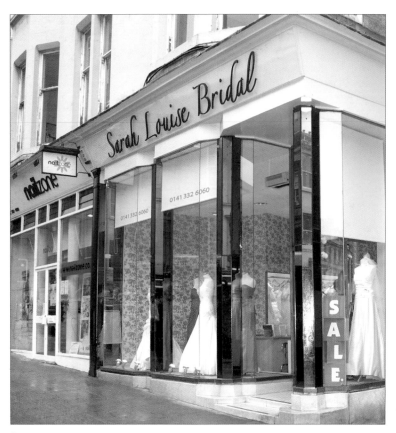

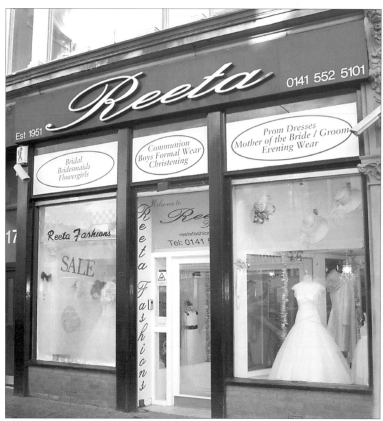

This photograph, *c.* 2009, shows the Sarah Louise Bridal Shop in Hope Street. It is a long-established bridal store and was previously known as Roberta Buchan. It is now owned by Lorraine Maclennan who worked in the shop before buying it. The name Sarah in the company's name is for Lorraine's daughter Sarah and the Louise for her late mother. The shop stocks a range of wedding gowns by leading designers such as Maggie Sottero, Allure, Impression, Ellis and Jasmine, many of which are exclusive to the Sarah Louise name. There is a full range of bridesmaids' dresses as well as a range of accessories including shoes, jewellery, tiaras and veils to complement the bridal ensemble.
Photograph by Alan Ferguson

Reeta Fashions was first established in 1951 in Maryhill Road. In 1955 the business moved to its present location in Gallowgate, shown in the photograph. There the business grew and by the end of the 1960s Reeta's manufactured and retailed approximately 4,000 coats per week with a staff of over 100 people. Although Reeta continued to prosper, retail trends changed during the 1980s and 90s, resulting in the company diversifying. It now concentrates on supplying only special occasion wear, such as everything for the bridal party – bride's dress and accessories, bridesmaids' outfits, flower girls' dresses, page boy outfits and of course, outfits for mothers of the bride and groom. It also holds a huge stock of communion dresses and prom dresses. *Photograph by Alan Ferguson*

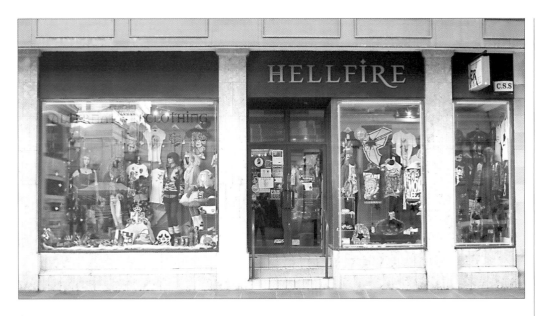

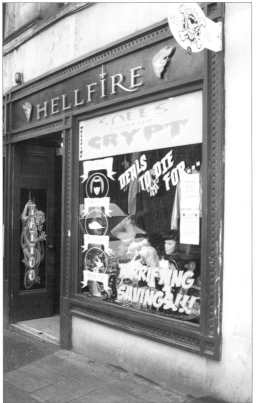

Hellfire is an alternative clothing company with three shops in the city centre, two in Queen Street and one in West Nile Street. Established in 1998, it has grown into one of Scotland's biggest outlets selling unconventional fashion. Labels cover a wide spectrum of styles.

46 Queen Street is home to Hellfire Couture, an alternative clothing boutique with a range of specialised brands to suit all occasions from designer street wear to 1950s pin-up to Gothic and burlesque. Among the items on sale are steel-boned corsets, killer heels and jewellery from Hollywood's favourite, Tarina Tarantino.

The shop at 86 Queen Street advertises itself as the 'one-stop shop for up to the minute Urban subculture'. It boasts a large selection of UV, gothic and punk rock style as well as jewellery, accessories, make-up and hair dye.

The West Nile Street shop is described as a treasure trove of dark wonders with a distinct horror theme. There are designer brand names such as Emily the Strange, Ironfist, Criminal Damage and Tuk. It advertises itself as having 'Offers to Die For, Clothing and Lifestyle for Ghouls and Gals'. The basement has a tattoo artist and there is a large range of piercing jewellery available.

Above. Hellfire shop at 86 Queen Street with interesting window displays, the one to the left having a green mannequin, pink wig, blue tutu style skirt and what in the centre looks suspiciously like neon coloured knuckle dusters. Bottom centre in the window to the right is what looks like a massive dog collar. *Photograph by Alan Ferguson*

Left. Hellfire at 105 West Nile Street that has a horror theme, as its window display show. *Courtesy Hellfire*

Up until the 1990s, there was not a High Street in Britain without a Saxone shoe shop, the name possibly being the most recognised in 20th-century British shoe manufacture and retailing.

Although Saxone began in 1908, its origins lie in the firm of Clark & Sons who began manufacturing shoes in Kilmarnock in 1820 and had by the 1850s established an export trade with Brazil and Europe. As Clark's Kilmarnock factory manufactured all the footwear exported to Brazil, the building of a factory in Sao Paulo left Kilmarnock's capacity exceeding the domestic and European markets. Clark therefore formed an association with brothers Frank and George Abbott of Northampton who had started their own business F & G Abbot in Liverpool in 1901. The association was mutually beneficial as Clark had manufacturing experience and factory capacity, the Abbots retail selling and merchandising experience. Both concerns operated from Kilmarnock, with Clark supplying only men's footwear.

In 1908 Clark and F & G Abbot merged, creating the Saxone Shoe Company and what gave it the edge over its competitors was that while they measured the length of the foot, Saxone introduced breadth fitting. It produced men's footwear in 30 half sizes with seven width fittings in each style, leading to the company's future selling slogan 'NO FOOT TOO DIFFICULT TO FIT'.

Saxone's selling techniques were so successful that by 1939 it had 141 shops and by the early 1950s was the leader in the women's fashion trade. Saxone amalga-mated with Lilley & Skinner and in 1962 the company became a division of the British Shoe Corporation. The Saxone name con-tinued on the high streets until the early 1990s.

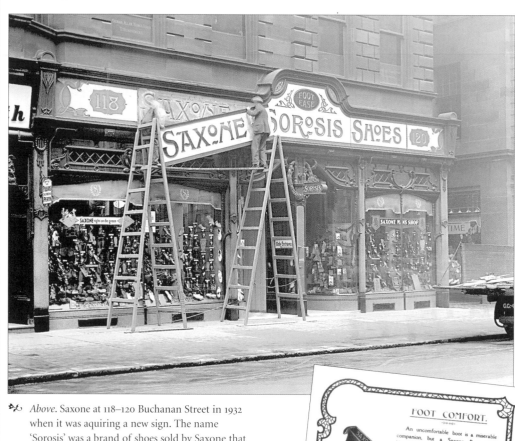

🙢 *Above*. Saxone at 118–120 Buchanan Street in 1932 when it was aquiring a new sign. The name 'Sorosis' was a brand of shoes sold by Saxone that were made in several fittings. The name was dropped when it was pointed out that it sounded like the unpleasant skin ailment psoriasis. *Courtesy Glasgow Regional Archives*

🙢 *Right*. Advertisement c. 1901 for Saxone at 118–120 Buchanan Street. It states NO FOOT TOO DIFFICULT TO FIT and that there were 5,700 styles and fittings of boots always in stock at the uniform price of 16s 6d – sounds a little like creative advertising.

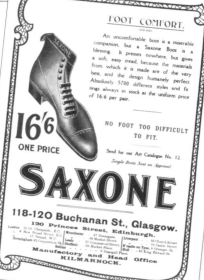

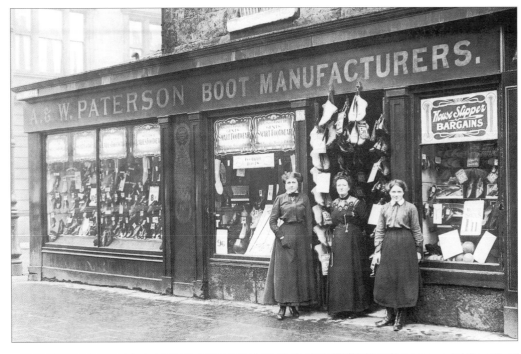

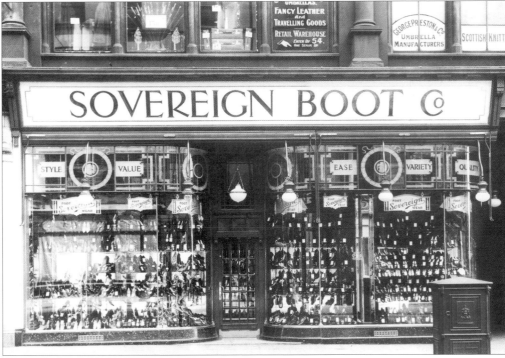

Top. The firm of A. & W. Paterson was established in 1820 and by Edwardian times had become the largest chain of shoe shops in Glasgow with 31 branches and a manufacturing works in Elcho Street in Calton opened in 1867. Eventually there were branches throughout Scotland. This photograph shows the shop at 476 Gallowgate in the early 1900s with three well-dressed staff posing outside it. The lady in the middle is particularly smart with a fob watch pinned on to her dress. All kinds of footwear were sold, from ladies' and gents' shoes and boots to football boots, slippers and ward shoes displayed in the window to the right – presumably for nursing staff. Brand names were Kelvin and Elcho. The firm was taken over by the British Bata Shoe Company, a subsidiary of the Bata Shoe Company established by Thomas Bata in Czechoslovakia in 1894. There are no Bata shops in Britain today, although there are in Europe.

Bottom. The Sovereign Boot Co. shop in Union Street in 1923. From the window displays there was no shortage of choice of footwear, ladies being given preference as the window to the left is packed with shoes for them while the window to the right is divided into two, children's shoes to the right, gents', to the left.

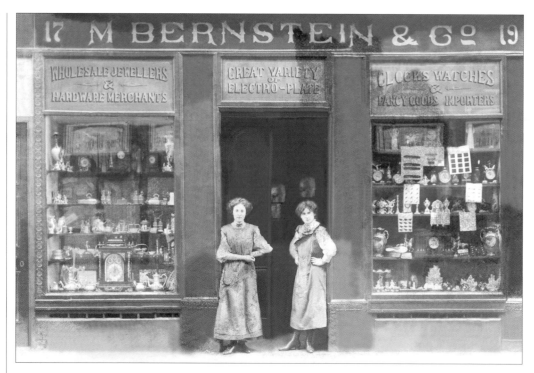

This photograph (bottom) shows Henderson's jewellery shop in Sauchiehall Street, which trades from one of Glasgow's treasured buildings, the Willow Tearoom, designed by Charles Rennie Mackintosh in 1903 for Miss Cranston. 'Henderson the Jeweller', was established in 1886 by Matthew McLaren Henderson in Coatbridge and is still owned and managed by the fourth generation of the Henderson family.

Matthew, the youngest of six children grew up in a mining community in Lanarkshire before starting as an apprentice with a local jeweller at the age of fourteen. Twelve years later he fulfilled his dream of seeing the Henderson name above the door of his own premises. It was not until 1925 that the business was incorporated into a limited company taking the name of the founder. Matthew retired at the age of 81 after a working life of almost 70 years. Today there are over 20 Henderson branches in Scotland, ten of them in Glasgow. The company prefers the personal touch of selling jewellery face-to-face with customers from their retail stores rather than by selling online.

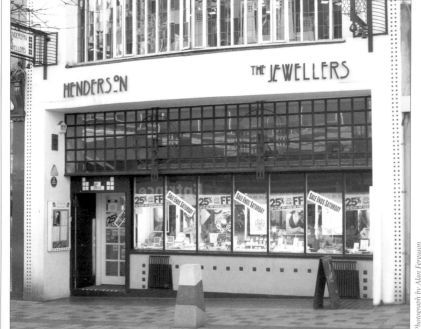

Photograph by Alan Ferguson

James Porter & Co. leased premises in the Argyll Arcade in May 1887, thus beginning the Porter family's association with the arcade which has never been broken, the company being the longest surviving tenant.

The Porter family's connection with the jewellery trade began when James Porter became a trainee watchmaker in Kilmarnock. In 1858, aged 21, he started his own business in Glasgow repairing watches for the trade. Before long he had premises (all upstairs) in Gordon Street, Buchanan Street and Royal Bank Place and it was from these addresses that the jewellery business evolved when he began to stock merchandise other than watches. He then opened a retail shop at 134 Argyle Street, but the crash of the City Bank on 2 October 1878, the greatest disaster that ever befell Glasgow's commercial community, forced him to cease trading.

In 1887 James opened a shop at 25 Argyll Arcade, which was stocked with high quality goods – watches, clocks, jewellery and fancy goods. In 1897, at the age of 16, his youngest son Gabriel joined his father at No. 25 thus beginning a family tradition of sons entering the business. As business prospered larger premises were required and in 1920 the shop next door, No. 26, was leased. A year later Nos. 25 and 26 were purchased and 1928 saw the acquisition of No. 24. All three premises were then combined into one shop with a large showroom above. In the 1960s Nos. 12, 13, 14 and 31 were added to the chain.

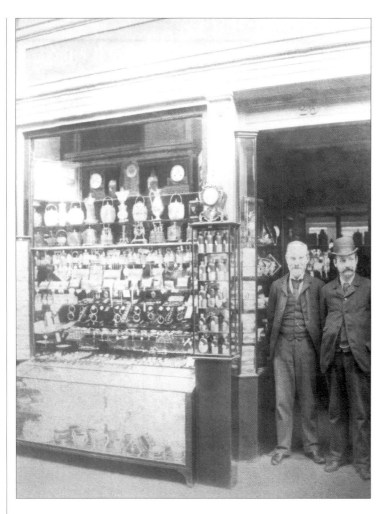

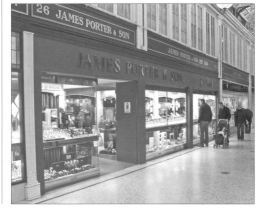

Above. Photograph showing James Porter (left) posing with a member of his staff outside his shop at 25 Argyll Arcade. James, who retired from the business in 1912, died in 1915. *Courtesy James Porter & Son*

Left. Photograph, *c.* 2009, of James Porter & Son's shop in the Argyll Arcade that encompasses three of the arcade's original shops, Nos. 24, 25 and 26 which were combined into one. No. 25 was the original shop. *Photograph by Alan Ferguson*

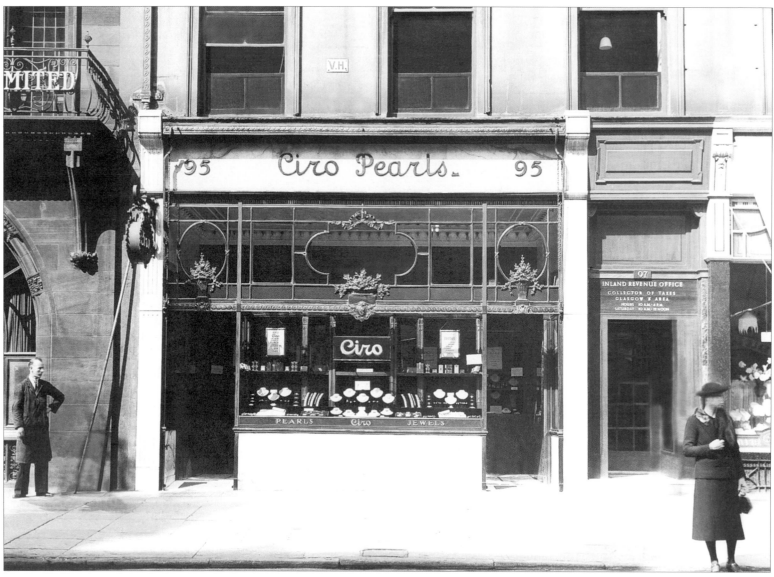

This photograph shows Ciro Pearls' shop in Buchanan Street in the early 1930s. Designed by George Boswell in Art Deco style, the frontage was encased in marble, a material favoured at the time for luxury shop fronts. The inside of the shop was an elegant salon. Ciro was founded in Britain in 1917 and for three years traded purely as a mail order company before opening its first shop. During the 1920s business flourished and Ciro Pearls advertisements appeared in all the influential women's fashion magazines. In 1928 when the company went public, it began a major expansion in the UK as well as extending its product range to include all areas of gold, costume jewellery and cultured pearls. In 1939 a flagship store opened in New York on Fifth Avenue, followed by stores in Beverley Hills and San Francisco and eventually throughout the world.

When the market shrank in the 1970s and 80s Ciro suffered, as did many costume jewellery firms, and in 1994 the worldwide business went into receivership. The UK arm was bought by John Shannon and it is now a family-owned and managed business, trading under the Ciro name, with a flagship store in the prestigious Burlington Arcade off Piccadilly in Central London.
Courtesy Glasgow Regional Archives

Chisholm Hunter is a well-known and respected name that goes back to 1857, when local wholesaler Mr Hunter established the company in Glasgow. Unfortunately, the whereabouts of its first premises is not now known but by the 1890s the business had relocated to 27–29 Trongate, a site it occupied for about 80 years. The addition of a Mr Chisholm as a partner in the early 1920s brought about the name Chisholm Hunter's, by which the business was to become familiar to future generations of Glaswegians. Post Office records from that time show the company listed as trading in 'Diamond Jewellery and Watches', although similarly to other businesses of its type then, it also sold other luxury goods including 'Gentlemen's Sporting Accoutrements'. After the Second World War the company moved its main premises to the Argyll Arcade, an establishment regarded as the 'Hatton Garden' of Glasgow and home to over 30 jewellers and diamond merchants. It was at this point that the 's' was dropped from the company's name, becoming simply Chisholm Hunter.

Over the decades Chisholm Hunter stores were opened in twelve different cities throughout Scotland and the North of England and in 2007 the company, still family-owned, celebrated its 150th anniversary by opening its fourteenth store. Today the company is the largest independent diamond assessor in Scotland.

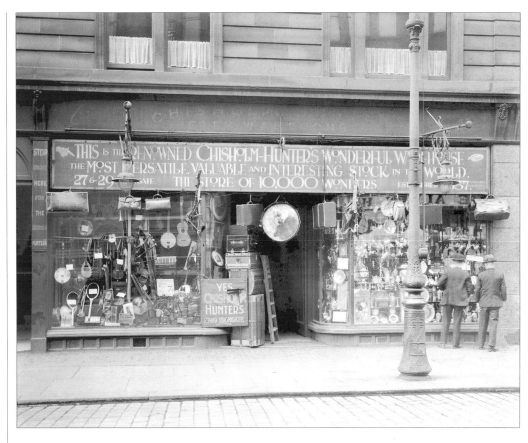

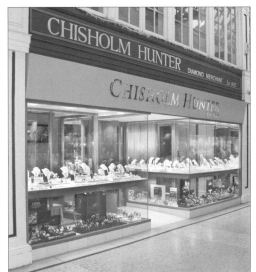

❧ *Above*. Chisholm Hunter's shop at 27–29 Trongate in 1932. The fascia board proclaims: 'This is the renowned Chisholm Hunter's Wonderful Warehouse, the Most Versatile, Valuable and Interesting Stock in the World. The Store of 10,000 Wonders.' It certainly did have the most versatile stock: the window to the left displays tennis racquets along with musical instruments. There is even a drum hanging over the doorway, which is stacked with luggage. The window to the right displays jewellery, silverware and antiques. *Courtesy Glasgow Regional Archives*

❧ *Left*. Chisholm Hunter in the Argyll Arcade in 2010, a contrast from the 1932 photograph of the shop in the Trongate. *Photograph by Alan Ferguson*

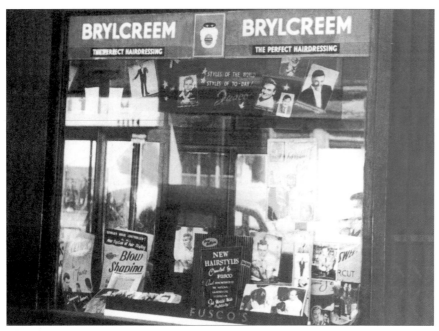

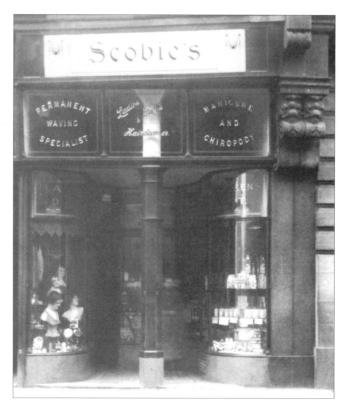

❧ *Above left*. This photograph shows Fusco's Barber shop in Cambridge Street in 1955. The window displays pictures of film and recording stars of the time. On the recording side there's Frankie Laine, Frank Sinatra, Johnnie Ray, Mario Lanza and Elvis Presley. Among the film stars are heart-throbs Robert Wagner, Robert Taylor, Rory Calhoun and Jeff Chandler. The shop specialised in crew cuts and the Tony Curtis style with its quiff was the teddy-boys' favourite. Essential to keep the quiff intact was Brylcreem, the perfect hairdressing according to the advertisement.

❧ *Above right*. For those living in the east end of the city, there was no need to travel into town for a fashionable haircut or beauty treatment for these were available at Scobie's establishment at Bridgeton Cross. This photograph shows the shop in the 1920s, the heads in the window on the left displaying the hairstyle popular with ladies at the time that went by a few names – the shingle, the Eton crop and the bob. The shop catered for men and women and as well as hairdressing it offered manicures and chiropody. Many still reminisce about the shop and how they got their hair cut there.

❧ *Right*. Today, Glasgow's favourite gent's barber shop is the City Barbers in West Nile Street, shown here in 2010. John Bonner, a sports fanatic with a talent for haircutting, founded it in 1989. Starting out with two barber chairs, some football and boxing programs on the walls and a small television showing recent events, he built up enough business through quality haircuts and first-class customer service to establish the busiest and most famous barber shop in Glasgow. The shop, whose walls are now covered in all different types of sporting memorabilia, has four large screens showing various sports. One factor has remained however: quality haircuts and excellent customer service which over the years has earned City Barbers the title of 'Glasgow's Original and Best'. As well as haircuts for a special occasion, gents can have a luxury shave. *Photograph by Alan Ferguson*

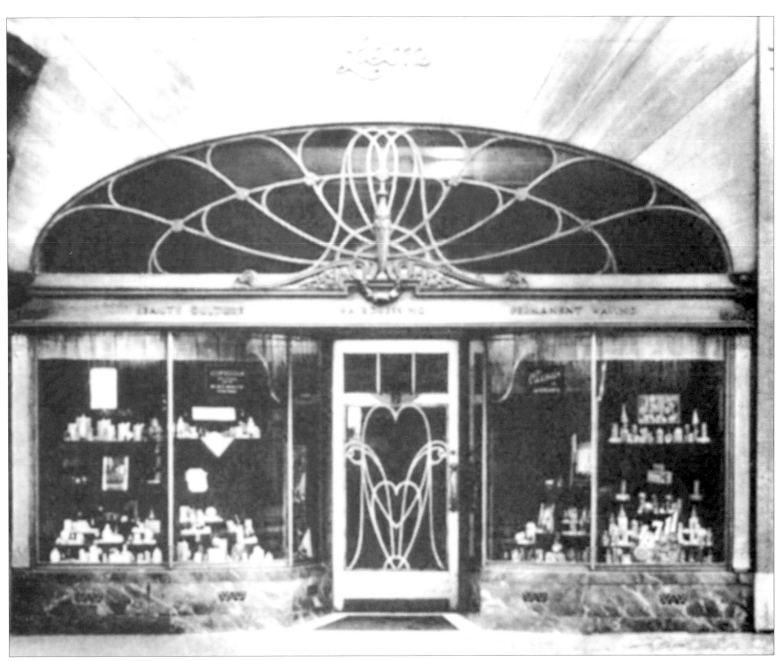

✌ Maison Leon at 89 St Vincent Street around 1930. It was a hairdresser and perfumier's salon and the building was the first of the works of one of Glasgow's most famous architects, Jack Coia. It was completed in 1928 and is a superb example of Art Nouveau style from the flowing stylised flower design on the door to the amazing metalwork decoration above symbolising a peacock with its tail fanned. In the 1950s Leon advertised that while its styles were decidedly avant garde, they were among the most reasonable of anywhere. A trim was 5s (25p); a shampoo and set 10s (50p).

Greaves Sports has three stores in Glasgow, two operating under the Greaves name and a Nike shop in Buchanan Galleries. The company also runs the Scottish Rugby store at Murrayfield Stadium, Edinburgh, as the official retail partner of Scottish Rugby.

The roots of Greaves Sports, a fourth-generation family business, can be traced back to 1930 when William Greaves bought out the Birmingham & Leyland Rubber Co. where he had worked as manager. The business was in Gordon Street, part of the premises dating back to 1803, while the rest was built in the 1920s with Art Deco influence. Renaming the company the Clydesdale Rubber Company, William sold coats, Wellingtons, sheepskin coats and rubber goods, all of which are detailed in old sales catalogues.

Change for the Clydesdale Rubber Company came in the 1950s with diversification into sports. The Dunlop Rubber Company had done so, forcing a lot of rubber shops to either move out of town or diversify.

When William Greaves died in 1958, the business passed into the hands of his sons Jim and Bill. At first under their leadership the business trailed behind another Glasgow sports shop, Lumley's, longer-established and better-known with a store in Sauchiehall Street. However, in the 1960s Greaves bought Lumley's in a surprise move as Lumley's had had its eye on Greaves. The two shops were run in competition with each other, Jim in Gordon Street and Bill in Sauchiehall Street. In 1967 The Clydesdale Rubber Company changed its name to Greaves Sports. Lumley's retained its name until 1990 when it also became Greaves Sports. When Bill retired he sold his share in the business to Jim and his children Sandy and Anne.

Today, the company, run by Sandy and Anne, has moved with the times by anticipating new trends and embracing new technology such as introducing a stringing machine, The Baiardo, once the preserve of tennis professionals. Named after the Greek mythical horse that had the ability to adjust its size to its riders, it was used by the official stringers at the US Open and Australian Open. The golf department introduced golf simulators while video analysis enables runners and skiers to get the best footwear. Apart from football, cricket, rugby and golf, the company's range of sports extends to running, hockey, fitness, swimming, martial arts and snowboarding.

The Gordon Street store has become a regular venue for photo-calls from footballing celebrities such as Henrik Larsson, Ryan Giggs and John Hartson. Famous customers include Frank Bruno and Eminem. Greaves has an enviable wealth of signed memorabilia and sports goods. Among it is a pair of boots signed by Rod Stewart, a jersey signed by Brazilian legend Ronaldo, a racquet signed by Ivan Lendl and books signed by Pele and Eusebio.

A major plus for Greaves is that it owns the Gordon Street premises and therefore has no rent to pay. In such a foremost shopping area of the city rent is extortionate and has caused many retailers to have to give up business.

From its beginnings as The Clydesdale Rubber Company, Greaves Sports has become a leading sports retailer with a reputation extending beyond Glasgow, Scotland and the UK.

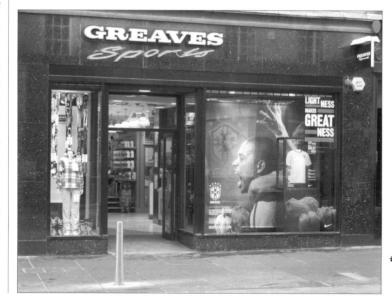

Greaves Sports shop in Gordon Street today.
Photograph Alan Ferguson

The Clydesdale Rubber Company shop in Gordon Street in 1960. The name of the shop changed to Greaves Sports in 1967. The window to the left is dressed for summer with swimsuits, bathing caps and a rubber ring. There is also an umbrella – a necessity for a British summer. *Courtesy Greaves Sports*

✣ *Above.* Postcard of Sauchiehall Street around 1915 showing Lumley's Athletic Rooms with Billiard and Bagatelle Tables. The windows advertise summer sports, winter pastimes and cricket.

✣ *Opposite.* Photograph of Lumley's golf club stand at a trade show in the 1950s. *Courtesy Greaves Sports*

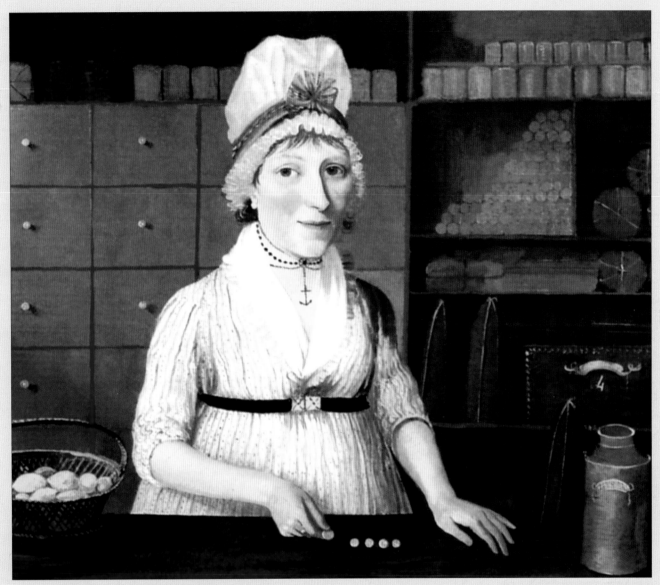

An 18th-century grocery shop in Glasgow. The packages are sugar and the only other food on display is lemons in the bowl to the left. The well-dressed assistant appears to be counting out money.

William Beattie opened his first bakery in Glasgow in 1876. His speciality Vienna bread suggests a higher class of clientele than that of most of his competitors. In 1913 Beatties began making confectionery and cakes, and Beatties Biscuits was founded in 1928 to cater for the famous Scottish sweet tooth. This advertisement is dated 1948.

This advertisement of 1950 shows seven Creamola products – A SWEET FOR EVERY DAY as the wording states. The company had been 'tickling the world's palate' since 1904 when the firm originated in Glasgow. Custard was the first product, followed by others such as rice creamola, sago creamola, blancmange desserts, milk jellies and lemonade crystals – the famous Creamola Foam. The company's logo was a Scotsman feeding the world.

This advertisement of 1975 shows that Malcolm Campbell sold not only fruit and vegetables but items such as soup, jam and soft drinks, all produced under the company's own name. Fresh food such as cooked meats, chicken, fish, cheese and bacon had also been sold since the 1960s. The business, begun by Malcolm Campbell in 1878, lasted until 2000 when the retail side closed.

Advertisement of 1947 for James Marshall, featuring the company's three branded products – Farola, Macaroni and Semolina. The company was founded in 1865 in Glasgow, but it was the launch in 1935 of its Short Cut Macaroni that turned it into a household name in Scotland. Marshall's Scottishness was emphasised by the use of tartan in its advertising. Marshall's is still Scotland's best-selling pasta.

❧ Advertisement for Bermaline bread of 1930. Bermaline, launched in 1886 by John Montgmery in Partick, was a loaf containing malt extract which it was claimed was suited for those with weak digestions. Claims were also made for its nutritional value, and by the end of the century, with 4,000 agents baking Bermaline bread throughout the UK, it had become a household name. John Montgomery was the first baker in Glasgow to wrap loaves individually.

❧ Leaflet advertising Templeton's Seasons Goodwill around 1940. A decorated fruit cake was priced at 2s. Shortbread was 1s 2d for a large cake and a flagon of Rose's Ginger Cordial was 1s 8d.

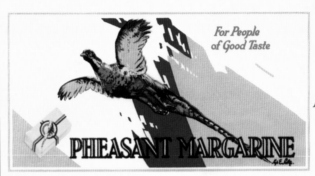

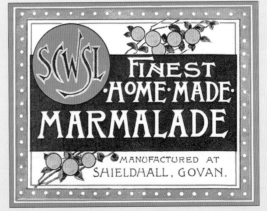

❧ Camp Coffee advertisement *c.* 1901. The firm of R. Paterson & Son introduced Camp liquid coffee and chicory essence in 1885. The name derived from that of its originator, Campbell Paterson. From its earliest days, Camp had a colonial military image, as the label on the product's distinctive, tall square bottle depicted an Indian sepoy serving a cup of coffee to a kilted British officer outside his tent in some far outpost of the Empire. The label has since been revamped.

❧ *Top.* An advertisement *c.* 1940 for A. Massey's own brand of Pheasant Margerine.

❧ *Above left.* Advertisement for SCWSL marmalade manufactured at the Co-op's massive Shieldhall factory.

❧ *Above right.* An advertisement of 1938 for Taylor's Love Bird Mixture prepared only by W. Taylor & Sons of Carrick Street, Glasgow. The company had been manufacturing seed for all species of birds since the end of the 1800s.

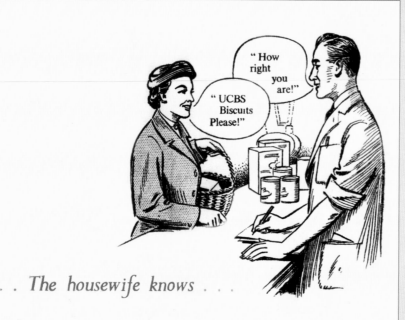

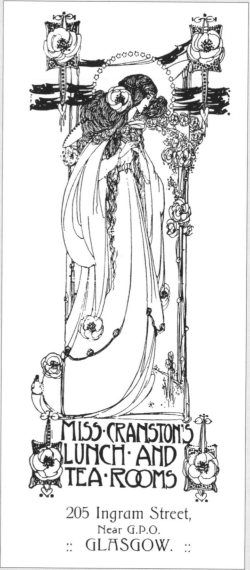

An advertisement from *c.* 1956 for UCBS biscuits.

An Art Nouveau-style advertisement for Miss Cranston's Lunch and Tearooms in Ingram Street which opened on 16 September 1886. They were designed chiefly for gentlemen, who had a commodious room. Ladies had to make do with a neat little apartment, 'almost an arbour', according to the *Bailie* magazine. A smoking room was opened a little later.

Say It With 'Flowers'

The Message of Flowers is Internationally Understood

Russell's

ℱlowers

ARE

PROPERLY SELECTED
PROPERLY ARRANGED
PROPERLY DELIVERED
ANYTIME — ANYWHERE

607-609
GREAT WESTERN ROAD
GLASGOW. W.2

Look for the F.T.D.A. Sign.
Florists, Telegraphic
Delivery Association
World Wide Service.

*Flowers-by-wire
"The Mercury way"*

PHONE · · · WESTERN 1666 (THREE LINES)
TELEGRAMS · · · · "LILAC." GLASGOW

❧ Glasgow has always had many flower shops, and this advertisement shows Russell's Flowers in Great Western Road in the 1930s. Before the advent of Interflora, orders for flowers could be sent at that time from one country to another by a telegraphic system.

LUMLEYS'
SPORTSWEAR for WOMEN

❧ A 1930s Lumleys' catalogue cover for ladies' sportswear. Lumleys' sports shop was in Sauchiehall Street and later became part of The Clydesdale Rubber Company, now Greaves Sports.

Perfumery

THE Perfumery Department on Street Floor is showing a delightful selection of High Class Perfumes, Soaps, Bath Salts and Toilet Powders, by all the celebrated makers, including:—Coty, Houbigant, Dubarry, Yardley and Colgate.

In the same Section will be found a fine display of Crystal and Coloured Powder Bowls, Perfume Sprays, Manicure Sets, and Toilet Brushes.

Wylie Hills

R. WYLIE HILL & CO., LTD.,
Buchanan Street and
Argyll Arcade.

X238Y 9 carat — £75. 15. X215DSY 9 carat — £239 X161 9 carat — £60. 15. X126DY 18 carat — £312 X177Y 18 carat — £193

The most fabulous watch in the world.

True beauty and precision seldom combine to such rewarding effect as in a watch masterpiece by Bueche Girod. Your choice of a Bueche Girod watch is rewarded by the admiring glances of those people whose good taste you respect.

Available from:

Edward & Sons Ltd

Bueche Girod

67 St. Vincent St., Glasgow C.2.
Tel. Central 7683

By appointment at your jeweller, luxury watches and jewels

❧ The cover of a Wylie Hill catalogue of the 1930s. The business was founded in the 1880s by Mr R. Wylie Hill in Argyle Street, his specialities being oriental merchandise, china and toys. In 1887 he moved into Buchanan Street, next door to the Argyll Arcade. The company produced catalogues for every occasion – weddings, Christmas, spring, autumn, holidays: no event was neglected. Bows acquired the business in 1925 but continued to trade under the Wyllie Hill name that continued until the 1970s when the store closed.

❧ An advertisement of 1975 for jewellers and silversmiths Edward & Sons Limited, established in Glasgow in 1838 and awarded a Royal Warrant from King Edward VII. The company was to Glasgow what Hamilton & Inches was to Edinburgh. There were two shops, one in London and one at the corner of Buchanan Street and Royal Exchange Place. By the time of this advertisement the business had moved to St Vincent Street.

An advertisement of 1948 for one of Glasgow's many shoe shops, Anne Gilmour in St Vincent Street. The 'Igloo Bootee' featured was manufactured by Brevitt, a respected make of footwear. In 1990 Brevitt Ltd was purchased by Rieker, a German shoe manufacturer established in Germany in 1845. Today the Brevitt brand specialises in wide fitting shoes and sandals.

An advertisement for Glasgow Corporation Gas Showroom *c.* 1911. It shows radiators and gas fires, and states that cookers could be hired at moderate rates and that fully equipped kitchen and laundry rooms were open for inspection. The water heater beside the bath looks rather dangerous.

ROYAL "DROOKO"

Glasgow Umbrella Manufactory.

Warehouses: {106 ARGYLE STREET,} Connected by
{48 ARGYLE ARCADE,} TELEPHONE.

JOSEPH WRIGHT, PROPRIETOR.

By *Rima* at McDONALDS LTD.

This Drooko advertisement was typical of Victorian times – pretty girls in an idyllic setting as this advert dated about 1895 shows. Drooko was the trade name of the Glasgow Umbrella Manufactory begun by a Coatbridge man, Joseph Wright, in the Argyll arcade in the 1880s. All his products carried a trademark – a dog called Wallace who held crossed umbrellas in his mouth, without which the article was not genuine.

An advertisement for McDonalds *c.* 1949. As can be imagined from the gown shown, McDonalds was a high-class establishment, and although essentially a ladies' fashion store, it carried household linens and a few menswear lines. The store in Buchanan Street was a retail hive off in 1913 from the wholesale business of Stewart & McDonald Ltd. In 1951 it was acquired by the House of Fraser.

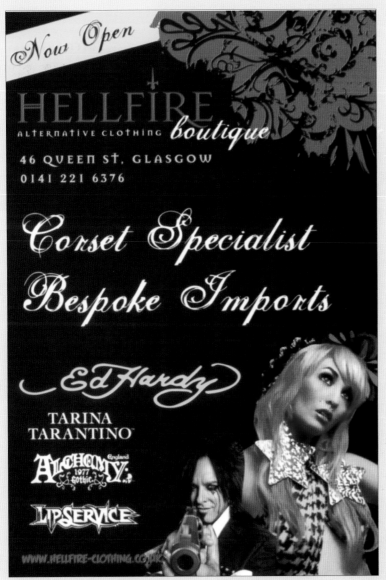

❧ Advertising postcard for
Hellfire boutique – corset
specialist – at 46 Queen Street.

❧ A Clydesdale Rubber Company
advertisement of 1950 for Dunlop
ladies' raincoats.

A Spectacle of ye olden tyme

For
UP-TO-DATE SPECTACLES and EYEGLASSES
try
TROTTER, LTD.
40 GORDON STREET, GLASGOW

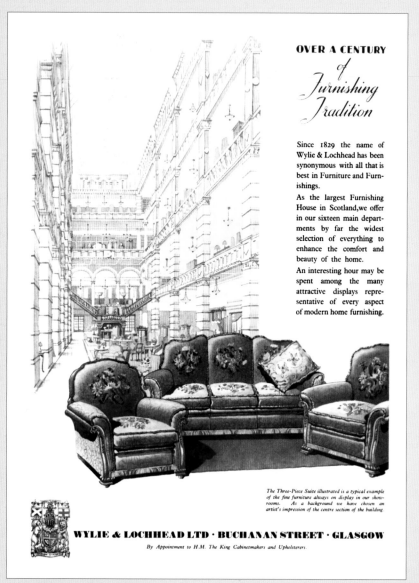

OVER A CENTURY
of
Furnishing Tradition

Since 1829 the name of Wylie & Lochhead has been synonymous with all that is best in Furniture and Furnishings.

As the largest Furnishing House in Scotland, we offer in our sixteen main departments by far the widest selection of everything to enhance the comfort and beauty of the home.

An interesting hour may be spent among the many attractive displays representative of every aspect of modern home furnishing.

The Three-Piece Suite illustrated is a typical example of the fine furniture always on display in our showrooms. As a background we have chosen an artist's impression of the centre section of the building.

WYLIE & LOCHHEAD LTD · BUCHANAN STREET · GLASGOW
By Appointment to H.M. The King Cabinetmakers and Upholsterers.

❧ In the past there were many independent opticians in Glasgow. This advertisement of 1938 is for Trotter in Gordon Street.

❧ An advertisement *c.* 1953 for Wylie and Lochhead which, as well as displaying furniture, shows the magnificent galleried interior of the store.

Mr B M Levine stands outside his Clydesdale Supply Company cycle and gramophone shop at 134 Saltmarket in the 1920s. As well as gramophones, the shop stocked musical instruments and records. There is a cycle hanging above the doorway and the window to the right displays gramophones and musical instruments such as banjos and drums. For ex-military and surplus radios as well as new radios, Clydesdale became the place to go and in 1937 it advertised that it took old radio sets in part-exchange and that easy terms were available, with immediate delivery. Glasgow-based Clydesdale grew into Britain's third-largest electrical and furniture retailer. Unfortunately, in 1994, it went into receivership and all the stores closed, one of the largest being next door to Arnotts at the corner of Jamaica Street. *Courtesy Scottish Jewish Centre Archives*

Harry Lauder and the Gramophone.

NO HOME IS COMPLETE
WITHOUT A
Gramophone & Melodeon.

Campbell's Patent Melodeons
are the best, 6/6, 7/6, 10/6, 11/- & 14/-

We are accredited Agents for all kinds
of **Gramophones** and **Records,**
as supplied to H.M. Queen Alexandra,
H.M. The Queen of Spain, His Holiness
Pope Pius X., His Majesty Amir of
Afghanistan, Madame Patti, Madame
Melba, Madame Tettrazini, Harry
Lauder, etc.

☞ A Post Card will bring you
our New Catalogue for 1911 of
all kinds of Musical Instruments,
Talking Machines and Records.

"OUR BRITHER SCOTS
FRAE THE COLONIES"
and other Visitors to the Exhibition
are cordially invited to inspect our
stock at either of the addresses below.

Harry Lauder's New Gramophone Records—"Just Like being at Hame,"
"The Message Boy," "Breakfast in Bed," "Queen among the Heather,"
"Tobermory," "Foo the Noo," "Wedding of Lauchie M'Graw," "Hi, Mr.
Mackie," etc.

CAMPBELL & CO.,
116 Trongate and 42 Sauchiehall Street
☞ (Opposite Empire Theatre),
GLASGOW.

❧ *Above left*. Biggars in Sauchiehall Street is Glasgow's
oldest music retailer. It began in 1867 and as well as
being one of the best-known outlets of its type in
the West of Scotland, it was Glasgow's favourite
music store, selling everything for music lovers
from sheet music to radiograms and Steinway
pianos. In 2008 it looked as though the shop might
close, but it survived, modernised with a coffee
shop on the ground floor and an on-line ordering
service. Biggars Music School is a great way to
learn to play a musical instrument in a fun, group
environment. It teaches guitar, drums, piano,
keyboard and singing. *Photograph by Alan Ferguson*

❧ *Left*. Advertisement c. 1911 for Campbell & Co
showing Harry Lauder standing beside a gramo-
phone. The message of the advert is: NO HOME IS
COMPLETE WITHOUT A GRAMOPHONE & MELODEON.
A melodeon is what we call an accordion today.

❧ *Above right*. For generations McCormack's music
shop in Bath Street has been synonymous with the
sale of instruments and musical supplies. Neil
McCormack started the business in 1937, arranging
orchestrations for bands and dances and teaching
accordion. In 1940 he opened a small shop in
Cowcaddens and in 1963 moved to Bath Street.

One of the old photographs adorning the stairs
shows The Rolling Stones who visited the shop in
1964 and caused such a hullabaloo that the police
had to be called as screaming girls mobbed the
street. It was so bad that Neil was ready to order the
Stones out of the shop for being responsible for the
commotion.

McCormack's has outlasted other specialist
music shops by knowing the business, evolving,
modernising and giving good customer service.
Photograph by Alan Ferguson

Glasgow's best known photographer was Thomas Annan, born in Fife in 1829. After serving an apprenticeship to a lithographer in Cupar, he moved to Glasgow and in 1855 he, and a young doctor called Berwick, set up a photography business at 68 Woodlands Road. Berwick soon left to pursue a medical career and in 1857 Annan moved to premises in Sauchiehall Street. Initially, a lot of work came from photographing paintings in houses and then persuading publishers to use these rather than engravings as illustrations in their publications. General landscape views were photographed then bound and sold as albums. To allow Annan to process his plates while on location it was reputed that he bought a hansom cab and converted it into a darkroom.

In 1859 Annan opened his own photographic printing works at Burnbank Road, Hamilton. In 1864 he lived next door to David Livingstone, whose photograph he took and then sold small prints of it for a shilling each. It was in Hamilton that he published views of 'Glasgow Cathedral' and 'Days on the Coast'. However, it was his series 'The Old Closes and Streets of Glasgow', taken between 1868 and 1871, that brought him world acclaim. At the time Glasgow had made a historic and momentous decision to rid itself of the privately-owned, disease-ridden, overcrowded slums housing most of its citizens and commissioned Annan to photograph them for posterity.

This postcard *c.* 1876 by Annan shows the High Street. The buildings, the last of Glasgow's famous arcaded tenements, were photographed before their demolition in the mid–1870s. The gabled buildings show the famous piazzas that once continued right along the buildings on the main street. There were always shops below the tenements and the two in the view appear to be general stores, the large one displaying a chair, numerous pails, buckets and washboards. Standing around are frock-coated, top-hatted gentlemen, one obviously posing for the photograph.

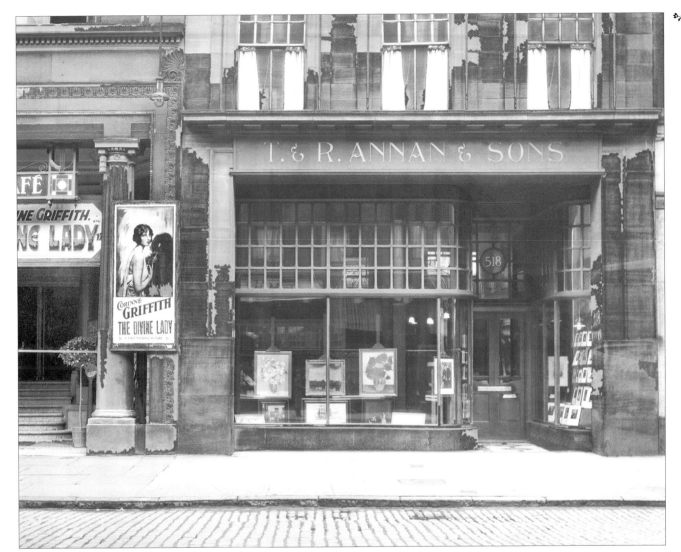

T. & R. Annan & Sons' photographic and fine art shop at 518 Sauchiehall Street in 1930. The building (now listed), which was designed by John Keppie and Charles Rennie Mackintosh, was occupied by the company in 1904. Next door to Annan's is the King's Cinema, originally the Vitagraph, opened in 1912. The film showing, *The Divine Lady*, starring Corrine Griffith, was a 1929 silent film telling of the love affair between Horatio Nelson and Emma Hamilton. *Courtesy Glasgow Regional Archives*

When Thomas Annan died in 1887 his sons carried on the business. After moves into two lots of premises in Sauchiehall Street, thanks to the profitability of the company's appointment as official photographer to the 1901 Glasgow International Exhibition, it was possible to build new premises in keeping with its high profile in the photography world. These were at 518 Sauchiehall Street, a narrow, four-storey, red sandstone, gabled building designed by John Keppie and Charles Rennie Mackintosh who was responsible for the wrought iron decorations on the magnificent lift shaft and the square, pierced beams. The lift took the customers up to the first floor photographic studio.

T. & R. Annan moved into its new home in 1904 and stayed there until 1959 when the War Department bought it as a regimental headquarters and museum for the Royal Highland Fusiliers, the regiment formed that year by the amalgamation of the Royal Scots Fusiliers and the Highland Light Infantry.

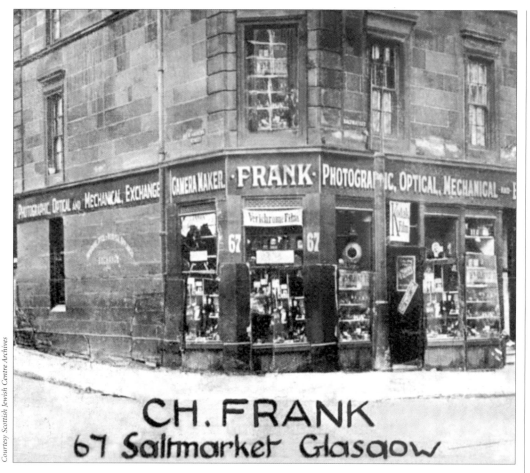

At one time a well-known name in the world of optical, photographic and scientific equipment in Glasgow was that of Charles Frank, who was born in Volkomir, Lithuania in 1865. To escape from persecution in Russia, he emigrated to Glasgow, settling at 104 South Portland Street in the Laurieston district of the Gorbals where he began business as a master mechanic. By 1910 he had set himself up as a camera maker with a shop at 67 Saltmarket for the design, sale and repair of photographic and scientific apparatus. Over the following half-century

Charles Frank Ltd, which later had another shop in Queen Street, became one of the best-known photographic centres in the city. The illustration is an advertising postcard *c.* 1920s for C.H. Frank's camera, optical and photographic shop at 67 Saltmarket.

Black & Lizars was formed by the merger of two of Scotland's best known firms of opticians, Lizars and C. Jeffrey Black. John Lizars, brought up in Berwick-Upon-Tweed, founded Lizars, the older of the two, in 1830 in Glassford Street where it remained for around 60 years. Renowned for optometry and spectacles, Lizars became a Glasgow institution and, in addition to the optical side of the business, John Lizars developed an instrument and lenses division, with an unequalled reputation for photography and scientific instruments.

John died in 1879 having built up a sizeable business and in 1892 his daughter Julie married Matthew Ballantine who took over the running of it. This dynasty has endured through four generations to Geoffrey Ballantine, today the joint chief executive of Black & Lizars.

From the 1880s practices were opened throughout Scotland and in the 1890s Lizars began to build their Challenge range of cameras at the Goldenacre factory in the east end of Glasgow. In 1892 Lizars moved to 101 Buchanan Street where it remained for 114 years.

The other half of Black & Lizars started with Colin Black, whose father had a small optician's shop in Shettleston. When Colin went to City University in London to study optometry in 1968, he began a friendship with co-student Shereef Taher. On graduating in 1973, the pair came back to Glasgow where Colin started a tiny practice in Pollokshields, 'C. Jeffrey Black'. Shereef found a job with Lizars in Buchanan Street and a short time later joined Colin in

Pollokshields. C. Jeffrey Black grew steadily and in 1999 the directors of Lizars and C. Jeffrey Black realised that to compete with the arrival of big business in optics a merger seemed appropriate and Black & Lizars was born. The company, with Colin as chairman and Shereef as a director, is Scotland's largest independently-owned optical chain.

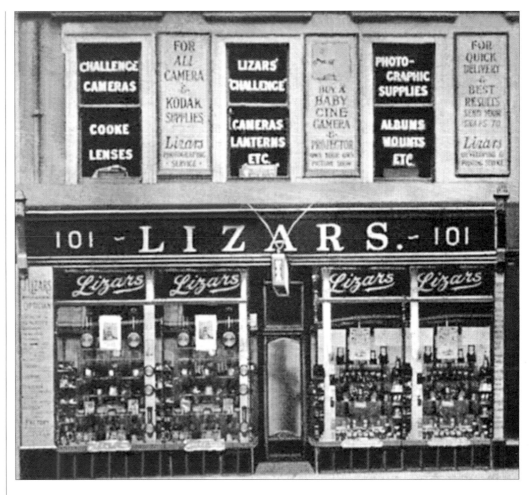

❧ *Top right.* An unfortunately poor image of Lizars' shop in Buchanan Street possibly taken in the late 1920s. The top windows advertise Challenge cameras and lanterns, a range that started in the 1890s. The company specialised in magic lanterns and lantern slides from the nineteenth century until the 1960s and hired out the equipment together with a 'Lanternist' to operate it. Also shown in the photograph is an advertisement for Cooke Lenses and one for a Baby Cine Camera and Projector. *Courtesy Black & Lizars*

❧ *Below right.* Black & Lizars' shop in Gordon Street into which the company moved in 2006. *Photograph by Alan Ferguson*

Many people think that homeopathic pharmacies are new to the high street. They are not, as this sketch, *c.* 1891, of M.F. Thomson's shop in Gordon Street shows. It opened in 1876 with a pharmaceutical department replete with every description of homeopathic medicine and preparations. To assist his customers, Mr Thomson produced a booklet 'The Concise Guide to Health'. This contained a mass of useful information in concise form with plain directions for the homeopathic treatment of common complaints and a list of remedies with indications for their use and suitable doses. Mr Thompson's speciality was his 'Prize Medal Kola' that was so popular he started a factory called the Lakola Works on the south side of Glasgow. The Kola Nut was procured from the West Coast of Africa and had long been used by natives to ward off fatigue and to sustain them on long journeys. The preparation was alleged to be five times more strengthening and nourishing than cocoa and among other things, to be invaluable for nervous and sick headaches and 'derangement' of the digestive organs. It came in various forms – Lakola Paste, Lakola Chocolate, Lakola Essence and Lakola Eucalyptus Jujubes allegedly used by Madame Patti and other eminent vocalists.

Another of Mr Thomson's preparations, Nervetonine, was advertised as a positive cure for practically every ailment – nervous debility, toothache, depression, indigestion, sciatica, lumbago, gout, loss of appetite and loss of memory. Where is this wonder cure today?

This photograph of May 1932 shows a traditional chemist shop, Cockburn's in Union Street. Judging from the photograph it had been raining when it was taken. It must also have been very cold at the time as one window is packed with hot-water bottles, the other with Thermos flasks. While the windows contain nothing to indicate that it is a chemist's shop, the fascia board advertises it as a druggist selling toilet requisites as did most chemist shops.

The company described its chemists as: 'THE MEN BEHIND.THE DOCTOR'. At the time the photograph was taken it advertised that prescriptions were dispensed by highly qualified and skilled chemists and that only the purest and finest ingredients were used. The advertisement went on to say that Cockburn's prices were as low as it was safe to pay and it did not consider any transaction completed until the customer was satisfied. It has to be remembered that at the time pharmacies mostly made up their own lotions and potions, not like today when they are all manufactured by the pharmaceutical industry. While there were branches in Glasgow and elsewhere in Scotland until the 1980s, when compared with Boots and Timothy Whites, Cockburn was a smaller pharmacy chain. *Courtesy Glasgow Regional Archives*

Glasgow's premier furnishing establishment was Wylie & Lochhead, whose reputation for artistic design and high quality craftsmanship went beyond Glasgow and Scotland. Originally a firm of undertakers, cabinetmakers and furnishers founded by William Lochhead and Robert Wylie in 1829 in the Trongate it was based from 1844 in Glasgow's first significant iron-framed warehouse at 28 Argyle Street. Trade grew steadily and in 1853 premises were acquired in Kent Road to house the funeral undertaking side of the business.

As, by the early 1850s, Buchanan Street was becoming the city's most fashionable shopping thoroughfare, Wylie & Lochhead located there in 1854 into a building designed by William Lochhead and described as 'without doubt the most handsome erection for business purposes in Glasgow'. The iron-framed warehouse had a façade of Corinthian pillars and plate glass and an arched glass roof. Inside, the departments were set out on galleries ranged around a central well.

By 1862 the firm was extensively offering a wide range of departments and services – household furnishing in Buchanan Street, funeral undertaking and post-horse hiring at Kent Road, cabinetmaking and paper staining at Kent Road and upholstery,

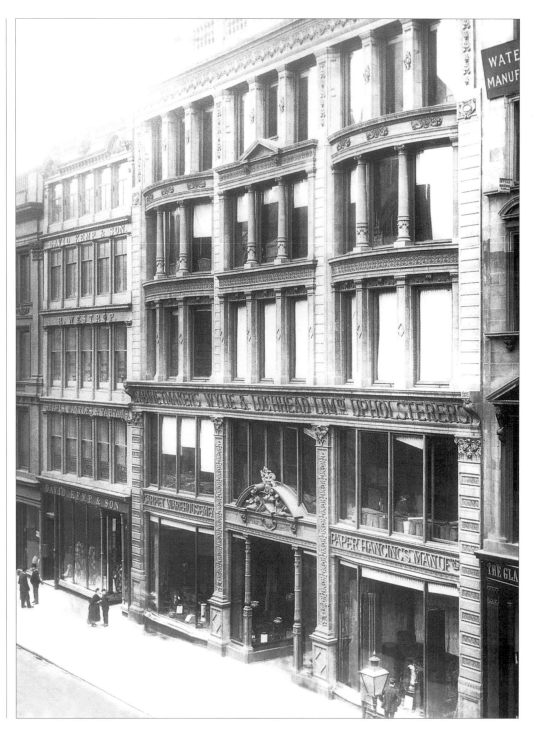

❧ *Right*. Wylie & Lochhead's store in Buchanan Street, built in 1885. Designed by James Sellars, its iron frame was constructed of fireproof materials with an ornamental terracotta façade. Inside were four galleried storeys lit by an arched glass roof reminiscent of the design of the earlier store on the site destroyed by fire.

carving and gilding at Mitchell Street.

On Saturday 3 November 1883 the Buchanan Street warehouse was destroyed in a fire that burned for hours. Temporary premises were found in Union Street and Glasgow architect James Sellars was commissioned to design a new building on the site, which was completed in 1885. Despite the setback in 1888 the business was awarded a Royal Warrant as cabinetmakers and upholsterers.

By the 1890s the cabinetmaking business was not only the largest in Scotland but was also pioneering Scottish avant-garde design as well as traditional styles. It spared no expense to secure the best talent in the art market and remarkable designers such as E.A. Taylor, John Ednie and George Logan worked for the company.

In the 1920s, the postwar depression affected trade and in 1929 the warehouse held its first sale – the Centenary Sale. The outlook remained gloomy in the early 1930s and when tastes in furnishing changed, the company was forced to buy in cheaper, manufactered furniture and introduce hire purchase.

In 1953 when the board was considering floating the firm as a public company to raise capital it received takeover bids from Waring & Gillow, Great Universal Stores and the House of Fraser. In September 1957 the House of Fraser offer was accepted.

The store retained its original character until 1966 when it was linked with its neighbour McDonalds, a fashion store acquired by the House of Fraser in 1951. Together they traded as McDonalds, Wylie & Lochhead. In 1975 the amalgamation of McDonalds, Wylie & Lochhead and Fraser Sons & Co. created a single department store – Frasers, on the west side of Buchanan Street. The funeral business continued as Wylie & Lochhead (Funerals) Ltd.

An advertisement, *c.* 1935 showing changes in Wylie & Lochhead furniture styles over a period of more than 100 years, from traditional to 1930s modernism.

Next to Wylie & Lochhead, A. Gardner & Sons in Jamaica Street was the most high-class furniture warehouse in the city. The building, dating from 1856, is the UK's oldest completely cast-iron-fronted commercial building. The structural frame was designed by Robert McConnell, who held the patent for its wrought and cast-iron beams. The façade, designed by John Baird I, was fashioned entirely in cast-iron and plate glass, the design following that of Paxton's Crystal Palace built for the Great Exhibition in London of 1851. While the building dates from 1856, the firm it housed is older, having been started in 1832 by Archibald Gardner.

Throughout the decades the business kept abreast of the latest trends in furniture and furnishings as well as stocking specialist furniture pieces. Practically every well-known make of furniture was available and if it was not, it could be ordered. As it also had departments for carpets, soft furnishings and bedding, there was no need to go anywhere else to furnish the home – that is if it could be afforded.

The business enjoyed an unbroken Gardner family tradition until 1985 when it was acquired by its Edinburgh rivals Martin & Frost. With the advent of companies such as MFI and IKEA with their flat-pack furniture, Martin & Frost closed and in August 2000, after refurbishment, the building re-opened as the Crystal Palace bar and restaurant.

Left. This drawing shows Gardner's amazing cast-iron building just after it was built. It is the UK's oldest completely cast-iron fronted commercial building.

Below. Photograph of Gardner's building when ownership had passed to its Edinburgh rival, Martin & Frost. The name A. Gardner & Sons cabinetmakers and upholsters still appears on the building as it does today.

In its heyday Bow's of High Street was a magnet for homemakers from every part of Glasgow and Scotland. Each Saturday over a thousand customers visited its vast furnishing galleries.

William Bow started the popular household business in 1873 in a tiny shop – the smallest in the street – with a ceiling only eight feet high and a 'step doon' inside the door. William traded partly by credit and partly by cash as was the fashion, but when he discovered his balance sheet was £7 out at the end of his first year's business he decided to trade only for cash. From then onwards he determined on 'Small profits – Quick Returns' and he let no opportunity slip to secure for his customers the advantages of buying for 'cash on the nail.' So the slogan 'UNQUESTIONABLY GLASGOW'S LOWEST PRICES' was created, and Bow built up a reputation for household articles of a quality and at a price second to none. When he held his first sale housewives came hurrying up the High Street, for Bow's bargains were genuine.

When the time came to expand, friends told him to go west. 'No' he said, 'I'm staying in the East because I'm convinced that I have laid the foundations of a good business in the High Street.' So, on ground adjoining his little shop, he built the great furnishing warehouse that became known as Bow's of High Street, the Home Furnishers.

William Bow was still the Chairman in the late 1930s and when he died the business continued to be controlled by the Bow family until it was acquired by R. Wylie Hill. Trading continued under the Bow name until the recession of the 1980s when the store closed.

❧ Drawing showing William Bow's first wee shop of 1873 and the giant emporium that grew out of it.

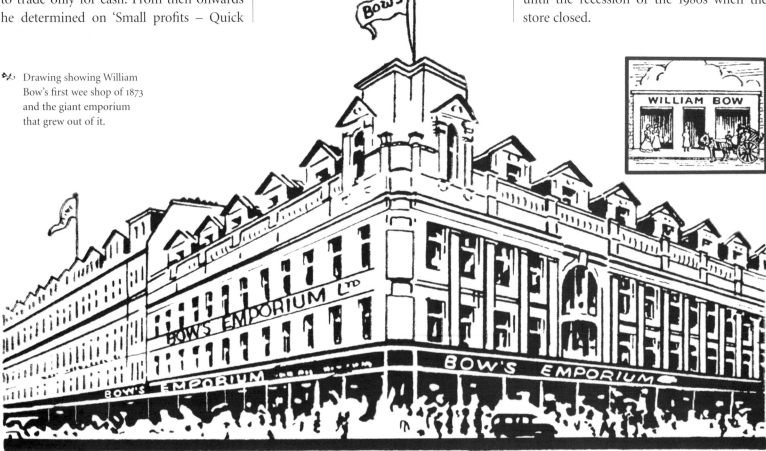

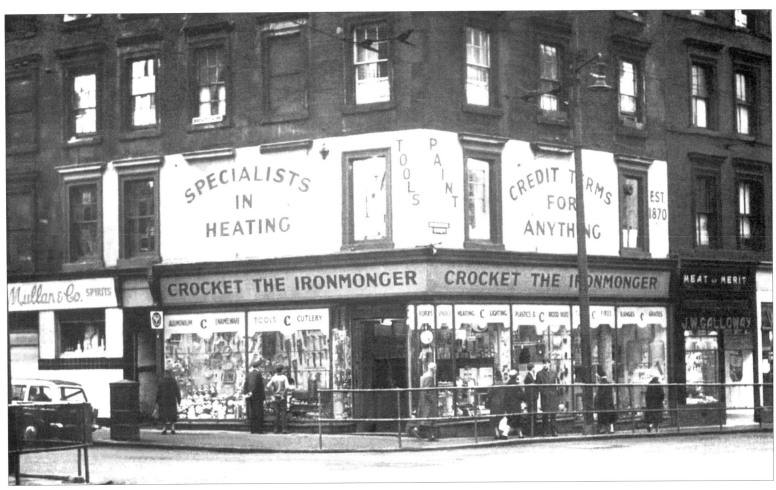

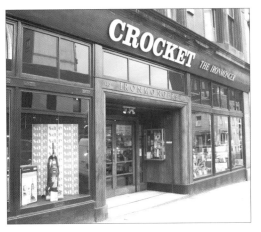

❧ *Above*. Crocket's ironmongery shop in Cowcaddens in the late 1950s. According to the advertising on the front of the building, it specialised in heating and there were credit terms for anything. The shop to the right is Galloway the butcher whose slogan was 'Meat of Merit'.

Crockets started trading in 1870 and is still family-owned, although it no longer trades from Cowcaddens, but from 136 West Nile Street. It also has shops in Falkirk and Ayr. It has survived by moving discreetly with the times. A traditional image is maintained on the shop floor but behind the scenes everything is computerised and while it cannot compete with the likes of B&Q in terms of quantity of goods offered, it concentrates on main-taining a broader range of stock, and on stocking all the smaller things people want and cannot get in the big outlets. All household essentials can be purchased, from pots and pans and doorknobs to gardening equipment, electrical goods, and power and hand tools. It also offers high tech midge-eaters and mole repellers. Diversification was the key to survival and Crockets caters for fishing, shooting and hillwalking customers. There is also an equestrian department.

❧ *Left*. The face of Crocket's ironmongery shop today. It still has a welcoming old-fashioned look. *Photograph by Alan Ferguson*

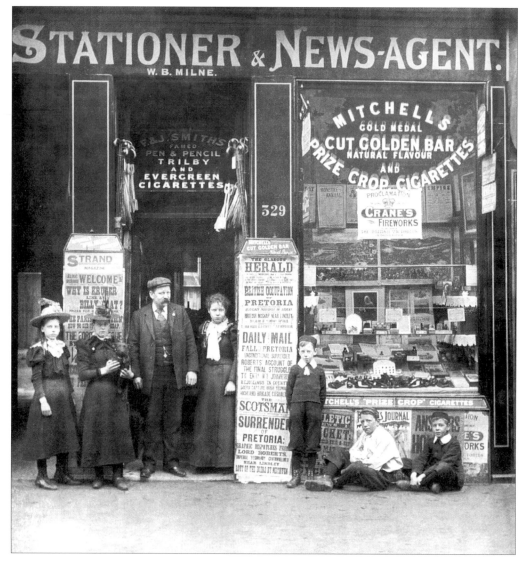

Above. An advertising postcard for bookseller and newsagent William Porteous & Co. Ltd in Royal Exchange Place, an institution known to generations of city users. The company still exists but the shop, Glasgow's oldest independent family-owned newsagent, closed in 1997.

The business began in 1853 in Exchange Square before moving to Buchanan Street and then Royal Exchange Place. It was founded by the Macfarlane family who were bankers, which is why the company was named after its first manager, William Porteous. Apparently, it was not the custom at the time for bankers to be involved in trade. At first the company employed men with barrows to deliver papers throughout Glasgow and then it opened the shop. The reign of Mr Porteous ended when he emigrated to Australia with the contents of the safe.

The shop was renowned for its stock of worldwide newspapers and exclusive stationery. It was also a haunt of seasoned travellers because of its extensive range of maps and guide books. A number of factors had forced the decision to close the shop. The work on the pedestrianisation of Exchange Square had made access to the premises difficult, hampering development of the existing newspaper delivery service. Also, the sale of newspapers through supermarkets had hit its traditional business and the building had changed hands. Today the company operates a newspaper and magazine delivery business in the Kingston area.

Right. Mr W.B. Milne posing outside his newsagent shop in Springburn Road with his family and staff. The well-dressed lady on Mr

Milne's left holding the small dog is probably his wife and the girl beside her in the fashionable hat, his daughter. The headlines on the newspaper placards proclaim the Surrender of Pretoria to Lord Roberts. As that took place on 5 June 1900 it exactly dates the photograph. The shop obviously catered for smokers, with pipes displayed in the window and the biggest adverts being for Mitchell's Prize Crop Cigarettes and Gold Medal Cut Bar tobacco. These products were manufactured in Glasgow by the firm of Stephen

Mitchell, which became part of The Imperial Tobacco Company in 1901 to combat American competition. Unmarried when he died, Mitchell left the bulk of his fortune to 'form the nucleus of a fund for the establishment and endowment of a large public library in Glasgow'. The library was to be for any class and no books were to be excluded on the grounds they controverted present opinions on political or religious questions. In 1877 Glasgow's famous Mitchell Library opened.

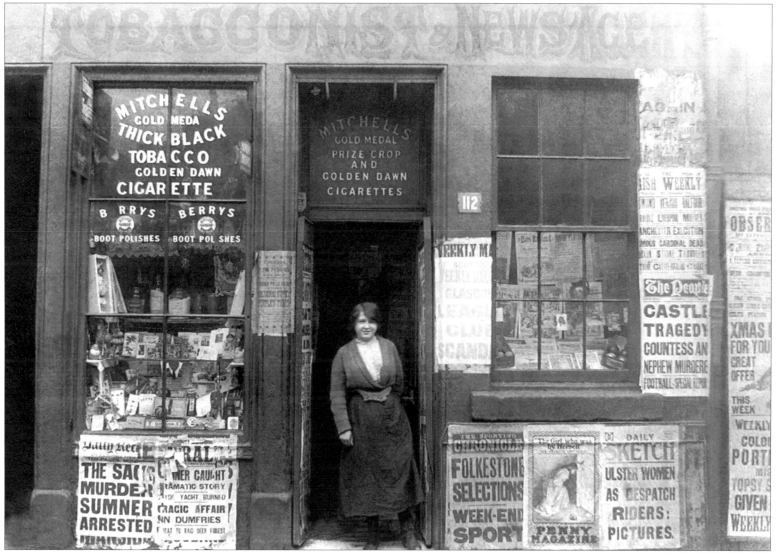

Newsagent shop at 112 Portugal Street, Gorbals. The photograph can be dated accurately as the headlines on the newspapers advertised on the left are about the arrest of the sack murderer Sumner, which took place on 21 December 1913. The murder for which George Sumner was wanted was of a particularly atrocious nature. Miss Bradfield, the manager of a tarpaulin factory in Liverpool had been beaten to death and her body sewn into a sack and thrown into a canal. Newspapers daily printed a photograph of the missing man, and for ten days police throughout the country searched for him. Ten days later he was found, calmly going about Liverpool undisguised except that he had shaved his eyebrows and wore coloured glasses. The window to the right is filled with comics and magazines while the one to the left has various items such as a doll in a box on the top shelf, which it is hoped, became a Christmas present for some lucky girl.

Glasgow's most prestigious stationery business was Lyon, who had premises in the Argyll Arcade and a large shop in Sauchiehall Street (shown in this photograph taken around 1900). The business, which advertised itself as Society Stationers and Artistic Printers, was begun in 1868 by William Lyon and carried on by subsequent generations of the family.

While the business thrived through the decades, the beginning of the end came on Monday 21 October, 1968, (the company's centenary year) when a lorry loaded with bricks careered down Garnet Street, swerved across Sauchiehall Street and crashed into the shop. Such was the force of the crash that the lorry was totally embedded inside the front entrance. The following day newspapers reported that one customer had died and a further 30 people were injured, four seriously.

Initially the building did not have to be demolished but was shored up and about two weeks after the crash the firm re-opened for business by operating four 'mini shops', one in part of the damaged shop and three in premises nearby. In 1970 Lyon gave up the Sauchiehall Street site and moved to premises in St Vincent Street. In 1973, the business, a Glasgow institution for 105 years, closed.

Courtesy Scottish Jewish Centre Archives

In Glasgow in 1901 there were 257 tobacconists listed in the Post Office Directory as well as sixteen cigarette manufacturers. One of the tobacconists was Nathan Kaplan who is pictured here in 1901 outside his Southern Cigar Depot at 35 Bridge Street. The window has a wonderful display of pipes with boxes of cigars placed below them. Above the pipes are boxes labelled Kaplantos, probably Kaplan's own label cigars. He also had his own Diamond Crop cigarettes. The establishment sold Mitchell's products, the most popular tobacco brand in Glasgow as it was manufactured locally by Stephen Mitchell's tobacco company. The statue on the plinth above right is exotically dressed in a turban which could indicate that he symbolised Turkish cigarettes and cigars. As to what happened to Mr Kaplan and his shop no-one knows as he left Glasgow to live in South Africa.

❧ *Below.* This illustration shows the lid from a box of Tam O' Shanter flake tobacco, as advertised on the board on the right shop front along with other Stephen Mitchell products produced in Glasgow in St Andrew's Square, just across the river from Kaplan's shop.

Robert Graham's specialist whisky and cigar shop in West Nile Street has a history that goes back to Glasgow in 1874 when Robert Graham set up business, establishing himself as one of Glasgow's respected tobacco dealers as well as a dedicated philanthropist and adventurer, with a love of whisky. He was City Treasurer for many years and was knighted for his services to the city.

In its heyday the firm had a chain of fifty shops and stalls from Aberdeen to Carlisle, with outlets in Glasgow in Argyle Street, Union Street, Buchanan Street, St Vincent Street and Central Station.

Eventually the only shop left, which had retained its original Edwardian interior, was in St Vincent Street. In 2003 Nigel Graham, whose great-great-grandfather set up the business, decided to sell it as he was finding it impossible to compete with the larger combines. The new owner was Ron Morrison, a Scots-born Florida restaurateur who invited Mitchell Orchant of Turmeaus Tobacconists, established in 1817 and based in Liverpool and Chester, to join him in partnership. The Graham family name was retained and today there are two Robert Graham shops, one in West Nile Street and one in Edinburgh.

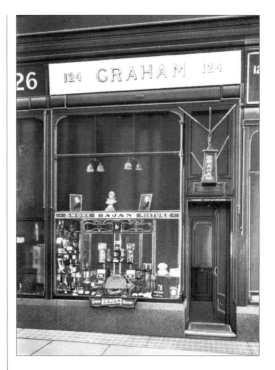
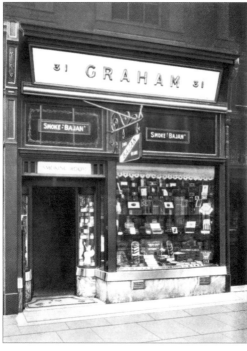
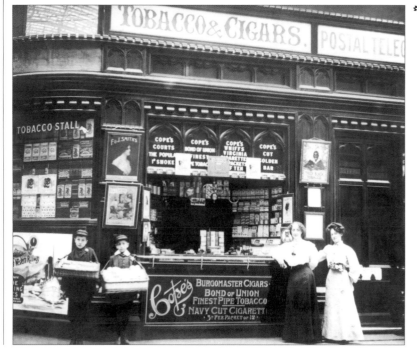

᠁ *Top left and right.* Edwardian photographs of Robert Graham's shops in Buchanan Street (left) and Gordon Street (right). Both advertise the company's famous Bajan tobacco blend. The Gordon Street Shop had a smoking room. *Courtesy Robert Graham*

᠁ *Left.* Marvellous Edwardian photograph of Graham's stall in Central Station with its two very fashionably dressed assistants posing in front of it. The boys must have sold the wares in their baskets around the station. The politically incorrect advertisement for Thick Black Tobacco showing a negro would not be allowed today. *Courtesy Robert Graham*

What was probably the oldest independent book shop in the world was that of John Smith & Son in St Vincent Street. It was founded in 1751 by John Smith, the youngest son of the Laird of Craigend, who started a bookshop in the Trongate to cater for the upmarket literary tastes of Glasgow's Tobacco Lords. Two years later he had established Glasgow's first Circulating Library, a popular and successful enterprise that maintained the largest collection of books in the city for more than 70 years. At its peak there were more than 7000 volumes in the catalogue. By 1757 Smith had moved to King Street and in 1763 back to the Trongate to a 'commodious' shop where, as well as books, he offered snuff and coffee. Book shops then were very much meeting places where people would come to chat and drink coffee.

When John Smith II took over the business in 1781, the most notable episode in his career was his connection with Robert Burns. The firm subscribed for 12 copies of the Edinburgh (1787) edition of Burns' poems, and apparently ordered a further nine copies. The story goes that when time came for settling accounts, Smith's bill showed a commission of only 5 per cent. Burns, contrasting this with Edinburgh charges, is said to have been amazed, and to have exclaimed: 'You seem a very decent sort o' folk, you Glasgow booksellers; but, eh! They're sair birkies in Edinburgh.'

John Smith & Son moved many times in its lifetime before finally settling in 1909 at 57–61 St Vincent Street where it stayed until 2000 when it closed, unable to compete with newcomers like Waterstone's and Borders. The oldest shop name in the city had vanished. The John Smith & Son name goes on however, and the company, the city's oldest trading company and oldest bookselling company in the English speaking world, is a specialist Academic and Professional bookseller operating over 28 sites in three separate countries.

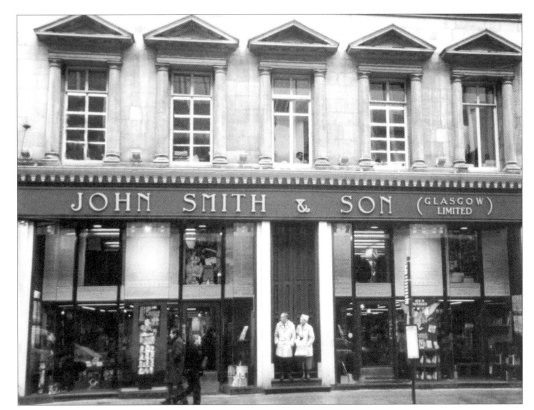

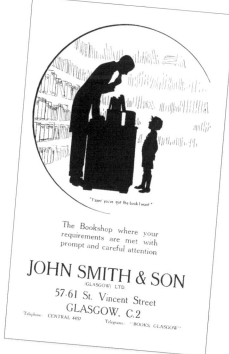

❧ *Left.* John Smith & Son's famous bookshop at 57–61 St Vincent Street.

❧ *Above.* Advertisement *c.* 1928 for John Smith & Son.

Trading from the same premises for over 100 years is Tam Shepherds Trick Shop in Queen Street, photographed in 2009 when the window was dressed for Christmas. Established in 1886, it is one of the oldest joke shops in the country. There was a real Tam Shepherd and in the 1930s Lewis Davenport, a magician who appeared at the Glasgow Empire, bought the shop from Tam's widow. The business is now managed by Ray Walton, who has been a magician for over 50 years. His wife Jean is the granddaughter of Lewis Davenport and their daughters Julie and Sarah help run the business.

The shop may be small but it is crammed with jokes, tricks and novelties. There are fake spiders and rats, rubber biscuits, buck teeth, hairy hands, whoopee cushions, itching powder and fake dog 'poo'. Professional and amateur magic tricks, including books, magazines and DVDs are available.

There is a selection of costumes, wigs, masks, make up and accessories and it is the place to go for Hallowe'en attire. Although fangs and witch hats are always popular, there are often crazes such as in 2007, when dressing up as Amy Winehouse was all the rage and people were asking for huge black beehive wigs.

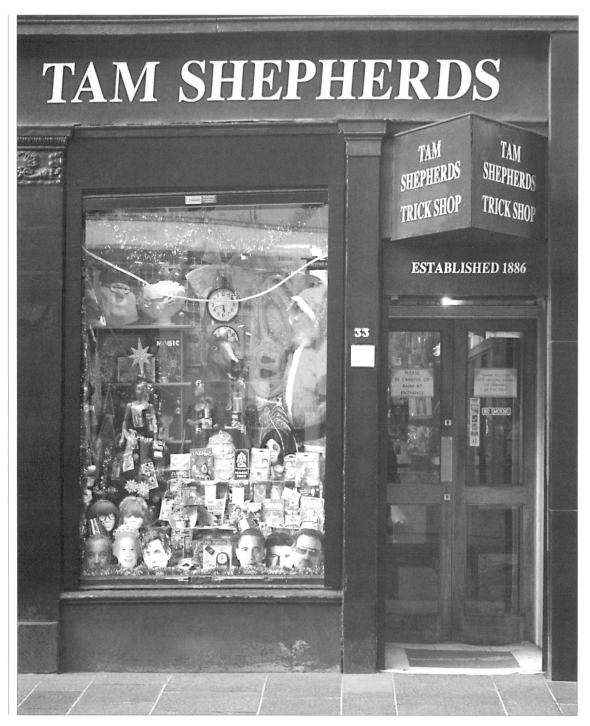

Millers Art Shop in Stockwell Street ranks amongst the largest and best in Britain with more than 175 years of experience in its field. Robert Miller established the business in the Gallowgate in 1834. A year later he moved to 186 Trongate where the business remained for 161 years until in 1996 it opened its flagship shop at 28 Stockwell Street where it offers a vast range of art, technical and craft materials.

On the art materials side, there is everything that the professional and amateur artist could wish for, with a wide range of paints, pastels and brushes from manufacturers such as Winsor & Newton, Daler-Rowney, Liquitex, Pro-Arte and Golden Acrylics. There is also a selection of freestanding drawing boards and easels. On the craft side, there are aisles of products such as specialist paint effects, stencilling, glass painting, face painting, modelling, jewellery making and card making. Millers is now run by the sixth generation of the family.

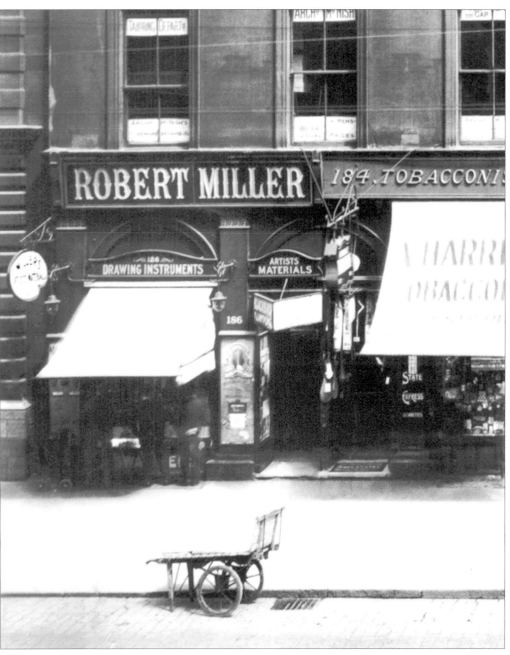

❧ Robert Miller's art shop in Trongate in the 1930s. The company moved into the shop in 1835 and eventually expanded into the tobacconist shop next door. *Courtesy Millers Art Shop*

❧ The modern face of Miller's art shop in Stockwell Street. *Photograph by Alan Ferguson*

On entering Hay's Pet Shop Street at the corner of Parnie Street and Osborne Street you immediately hear the chattering of canaries, budgies, cockatiels and the other birds on sale. Also on display are fish, hamsters, rabbits and guinea pigs. The shop is owned and run by Robert Wilson and his sister Moira.

Originally the pet shop was owned by Tommy Hay but after the Second World War he had enough of running it and wanted to retire. Bert Wilson, who owned a fruit shop in Saltmarket, bought it and out of respect to Tommy retained the original name. Bert's son Robert took over the shop in 1965.

The shop is a Glasgow institution with many remembering when puppies and kittens were displayed in the window. It is the most photographed shop in the city as returning expatriates cannot believe it is still there. Rich and famous have been its customers. Rickki Fulton used to pop in around the time he was filming the TV show *Francie and Josie* and a couple of mynah birds in the shop who were great talkers would come out with Francie and Josie's phrases. The shop achieved worldwide exposure when the exterior, transformed into North Books, became the backdrop for most of the action in *Wilbur*, the dark Scottish comedy that was a hit at the Berlin Film Festival and the Edinburgh Film Festival in 2003. It was also seen on television in *Chewin' the Fat* and *The Crow Road*.

❧ Thomas Hay's Pet Shop and Aquarium Corner. A banner in the window humorously says 'The Pet Shop Boys'. It must be one of the oldest shops in the city as it has been standing since 1881. *Photograph by Alan Ferguson*

PART 3
Shopping Centres

The Argyll Arcade, which opened in 1828, is the earliest covered shopping centre in Scotland and the largest specialist jewellery outlet in Britain, if not Europe. It was the brainchild of mahogany exporter John Reid, whose premises in Morrison's Court were gutted by fire in 1827. After the ground was cleared he wondered how he could use the site to its greatest advantage. What he came up with was a covered walkway, shop-lined, with buildings of a restricted height that would link Argyle Street with Buchanan Street. However, having no such guide in Scotland, he visited London in search of a prototype. Finding nothing inspiring, he went to Europe where he studied the latest ideas in shopping habits, particularly arcades.

Having decided what he wanted, Reid asked architect John Baird to build a covered arcade to provide shops for the local gentry who lived nearby in what was then the west end of the city. Two buildings belonging to the Reid family were to be used as entrances to the arcade – a tenement in Argyle Street and one of Buchanan Street's original mansions. The final L shape of the arcade was predetermined by a place already built on the west side of Morrison's Court. John Baird's use of a hammer-beam roof with iron tie bars was unique among arcades.

When the arcade was built, it was a highly speculative, adventurous gamble, Buchanan Street being still very much a country road leading to Port Dundas. Fortunately, it quickly became a centre for quality goods and was mainly responsible for the rapid expansion of Buchanan Street as it

❧ *Opposite*. Photographed in 2010, the 1904 French-Renaissance-style red sand-stone block that in 1904 replaced the old mansion fronting the arcade.

❧ *Left*. The building that originally fronted the Argyll Arcade at its Buchanan Street end. The house belonged to the origi-nator of the arcade John Reid, and the arcade's entrance was driven through the house's front door. The Reid family lived in the top part of the building.

diverted a large proportion of pedestrian traffic from busy Argyle Street into the calm retreat of the newer street. (The difference between the spelling of the Argyll Arcade and Argyle Street arose because people spelled names any way they chose in times past, and there are as many Argyles as Argylls on maps then. Today Argyll is accepted as correct.)

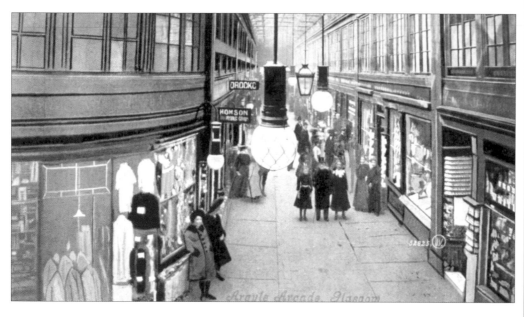

Above. Postcard, *c.* 1908, showing well-dressed shoppers strolling in the arcade.

Right. Mrs Diack and her staff photographed outside Mrs Diack, Children's Outfitters in the 1890s.

The shops were intended for patronage by the gentry as among the goods they sold were guns, jewellery, silver, musical instruments, flowers, wigs, glass, pottery and wine.

In 1889, Stuart Cranston, the man who invented the tea-room, opened a suite of tea-rooms and a dry tea retailing shop on the south side of the arcade's Buchanan Street entrance. Eventually he bought the whole arcade and in 1904 replaced the old mansion in Buchanan Street with today's French Renaissance style red sandstone block.

The arcade's original shopping layout was planned to ensure that a varied choice of quality goods was on sale and over the years there have been many well-loved shops trading there. Among these was the Clyde Model Dockyard, a mecca for boys of all ages, as it sold Hornby trains, model yachts and planes, lead soldiers and the popular Meccano set. Also fondly remembered is Mrs Diack who sold children's clothing. Catherine Diack, who hated housework, hated being confined to the house and was bored despite having nine children, started a small business in Crown Street making and selling babies' and children's clothes, all hand stitched and exquisite. She moved to the Argyll Arcade and in 1869 Mrs Diack Children's Outfitters' appeared on the fascia board above No. 58. The shop continued trading until the 1980s.

Today, with the exception of Greggs at the Argyle Street entrance to the arcade and Sloans Restaurant, all the outlets are jewellers, the oldest being Porter & Sons, who have been in the arcade since 1887.

The opening of the St Enoch Centre in 1989 introduced an entirely new concept of shopping to Glasgow as it was the city's first shopping mall. It consisted of 75 well-known high street shops, a food court, an ice rink and parking for 750 cars. The largest tenants were Debenhams and British Home Stores. To create the centre, the Victorian St Enoch Hotel was demolished, a desecration still talked about. Although the centre's massive glass canopy did not meet with architectural acclaim, the structure became a landmark nicknamed 'The Glasgow Greenhouse'.

On the centre's tenth anniversary a refurbishment programme, initiated to compete with the newly opened Buchanan Galleries, saw the ice rink closing and the area being replaced by shops and an enlarged restaurant area.

As often happens with imaginative architecture, it ages quickly and by the start of the twenty-first century the centre was looking tired. It was therefore decided to enlarge and improve it. The main problems were that the entrances were tucked away from the main pedestrian flow and the centre was hidden behind a row of existing shop fronts. The solution was to reconfigure the centre, creating a new entrance on Argyle Street where it meets Buchanan Street, Glasgow's most desirable shopping area. To create a more vibrant outdoor area the centre was extended into the square around St Enoch's former subway station.

On 26 November 2009 the first phase of the refurbished centre opened with 40 new stores, the centrepiece being the world-famous toy retailer, Hamleys, founded by Cornishman William Hamley in London in 1760. The St Enoch shop was the firm's first flagship store outside London and Hamleys had decided to open the shop in Glasgow because of the city's official status as the best retail centre next to London. The store has a Glasgow touch, with a frieze featuring famous landmarks including the Science Centre, Clyde Arc Bridge (Squinty Bridge) and Kelvingrove Museum. There's a cubicle where children can try on the array of fancy

❧ A view from Howard Street of the massive glass-canopied St Enoch Centre, affectionately known as 'The Glasgow Greenhouse'.
Photograph by Alan Ferguson

dress costumes on offer. Shoppers can enter the store via an escalator in the new 'glass box' addition created as part of the mall's extension.

Among the new stores is the official Formula One merchandise store, Wheels of Sport. There's also trendy scooter company Lambretta, famous for its connection with mods and rockers in the 1960s. Lambretta began in Italy in 1944 and the mopeds were designed as a form of cheap transport for the masses. They were inspired by bikes used by American soldiers to carry messages during the Second World War.

✣ Viewed from Buchanan Street, the new 'glass box' addition to the St Enoch Centre that contains Hamleys' toy shop opened in November 2009. *Courtesy St Enoch Centre*

Princes Square, Scotland's leading speciality shopping centre, was originally a four-storey merchant square with an open courtyard and stables, which was built in 1841 to a design by architect John Baird. The owner, and then Lord Provost of Glasgow, James Campbell, received a knighthood from Queen Victoria and in celebration of the birth of the Prince of Wales he named his new building Prince of Wales Buildings.

In preparing the design for the shopping centre the architects wished to preserve and restore the original buildings and yet transform it into a modern shopping centre, 'a new Rialto', a meeting place where people could shop, dine and be entertained. What they came up with was a style inspired by the spirit of the golden age of Glasgow in the 1890s, a time when the city had strong links with the Art Nouveau Movement and the Vienna Secession. The chosen theme was the Tree of Life that stemmed from Celtic and Norse legend and was central to the Glasgow coat-of-arms.

When the centre opened in 1987 shoppers were astonished to find that the narrow Buchanan Street entrances opened out to reveal a stunning, spacious four-storey complex. While the walls of the Prince of Wales Buildings formed the sides of the square, a clear glass roof covered the space creating the feeling of an airy Victorian conservatory. The Grand Staircase went from left to right and the curved landing between each flight allowed people to stand and look around and admire the sumptuousness of their surroundings. On either side of the staircase, glass lifts had been used as towers to frame the original east wall of the square, which was remodelled to become a Palladian screen. There were also banks of escalators.

Princes Square has a mix of high street brands, designer labels and independent boutiques. Among the outlets are Vivienne Westwood, Kurt Geiger, Vidal Sassoon, Illuminati and Crabtree & Evelyn. The centre is home to ten of the city's top restaurants as well as cafés and bars. Adding to their desirability, they are open until midnight, stimulating a relaxed and cosmopolitan 'café' culture sheltered from the elements.

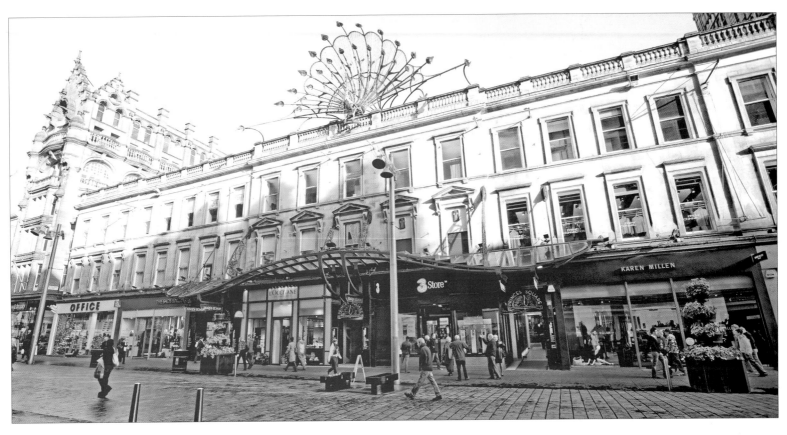

Above. Prince of Wales Buildings from Buchanan Street. To entice the passer-by to discover 'The Square', glass arched canopies with flowing metalwork in organic shapes extend out over the pavement. Perched on top of the building is a giant stylistic metalwork peacock. *Courtesy Princes Square*

Left. View of Princes Square's magnificent glass roof and the glass lifts that are topped with metalwork decorated with an Art Nouveau trailing leaf pattern. The back wall was remodelled as a Palladian screen.

Glasgow's reputation as the top shopping venue in the UK outside London was boosted in 1999 with the opening of the prestigious £200-million Buchanan Galleries set beside the Royal Concert Hall at the north end of Buchanan Street. Until work began on the construction of the Galleries in 1996, the site had lain derelict for ten years. The brick, sandstone and granite structure, which has a design life of 100 years, complements the city's civic architecture.

When opened, the Galleries housed 80 outlets, one third new to Glasgow and a quarter dedicated to fashion with names such as Gap, Oasis, Jeffrey Rogers, Miss Selfridge, and stylish Spanish fashion chain Mango, launched in Barcelona in 1984. Leisure and sportswear were covered with Nike and Levi. There were also stalwarts like Boots that no shopping centre could be without.

While the cornerstone of the complex was the John Lewis department store, the company's first in Glasgow and its largest, covering 300,000 square feet, half the overall size of the Galleries, next in importance was furnisher and home goods retailer Habitat (now closed). It was the company's largest

❧ *Left.* The Grand Staircase flanked by the glass lifts. Tucked underneath the staircase is an entertainment area equipped with a grand piano. *Photograph by Alan Ferguson*

❧ *Opposite.* Photograph of the outside of Buchanan Galleries taken in 2009. *Photograph by Alan Ferguson*

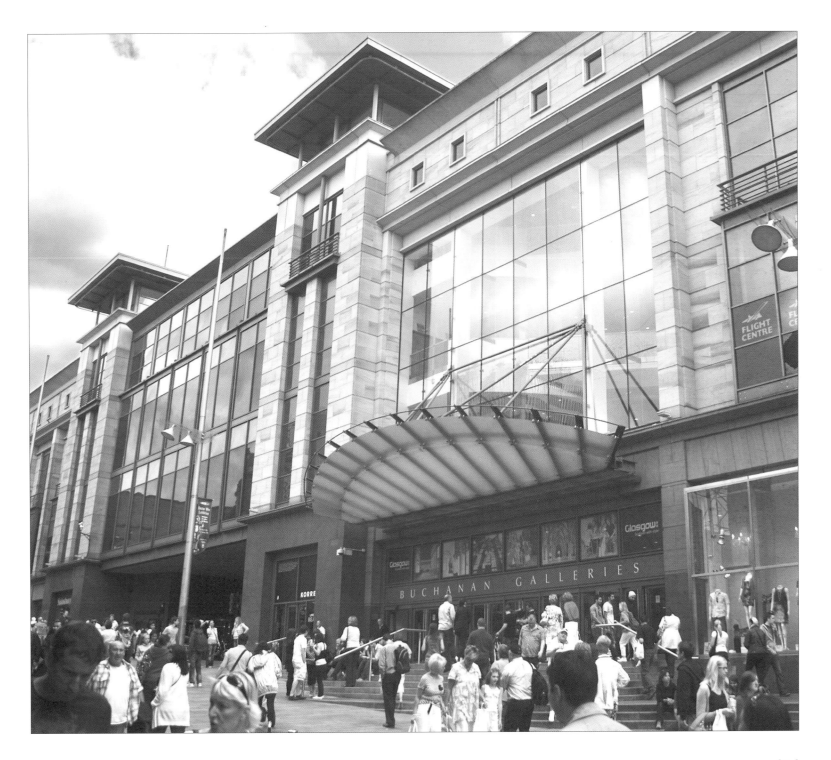

❧ Interior of Buchanan Galleries showing how light and airy it is. *Courtesy Buchanan Galleries*

store in Europe and incorporated the Café Gandolfi, which enjoyed a stunning position high up on the mezzanine level from where customers could enjoy superb views of life in Buchanan Street below. Nine escalators and 20 lifts helped shoppers negotiate the huge complex and find their way to the six food outlets.

PART 4
Chain Stores

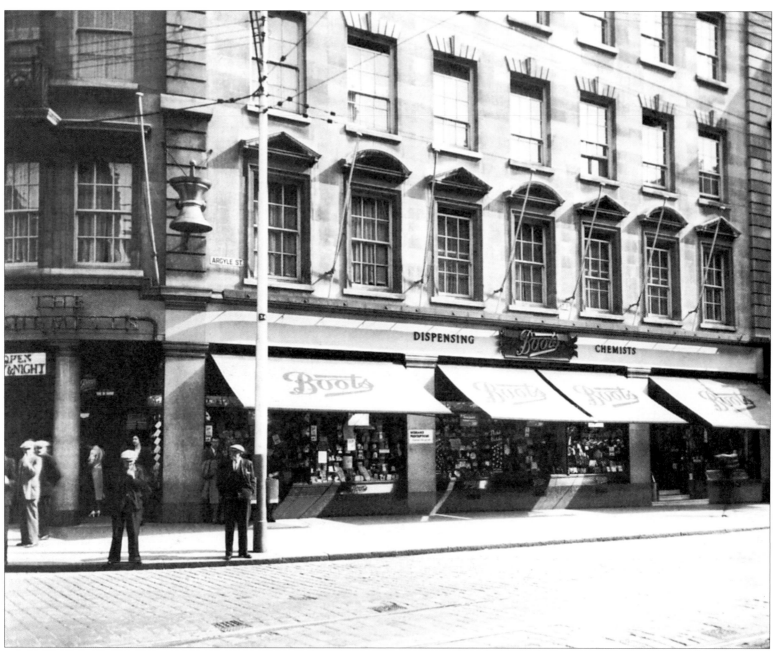

❧ *Above*. The corner of Argyle Street and Union Street, known as Boots Corner, was a favourite meeting place as everyone knew where it was. This photograph shows Boots' store in 1938.

❧ *Opposite*. Boots in Sauchiehall Street in 1955.

Out of all the chemist shops in Glasgow, Boots is the first port of call when looking for pharmaceutical products. The story of the business is that of the founder Jesse Boot. Born in 1850, he was ten when his father died and 13 when he left school to help his mother in her tiny herbal shop in Goose Gate, Nottingham. When his mother handed the shop over to him in 1877 he added household goods and proprietary medicines to the stock. He had wanted to launch a remedy of his own but, lacking capital, decided to sell a range of other people's medicines at cut prices.

In 1884 the first Boots' pharmacist was appointed and when the first manufacturing company was created in 1888 it was called the Boots Pure Drug Company Limited. Jesse also started a manufacturing division for his own products, the forerunner of today's massive 'Boots Own Brands' organisation.

When the company celebrated its Centenary in 1977, an article in *The Times* recording the story of Jesse Boot, said 'Today, there are 1,250 shops that carry his name … and it is barely possible for a Briton to imagine shaving, or changing the baby, or curing belly-ache or hangover, without Boots. But this week a hundred years ago it was just a gleam in the eye of a young man with some home-picked samples, big ideas and a weekly turnover of £20'.

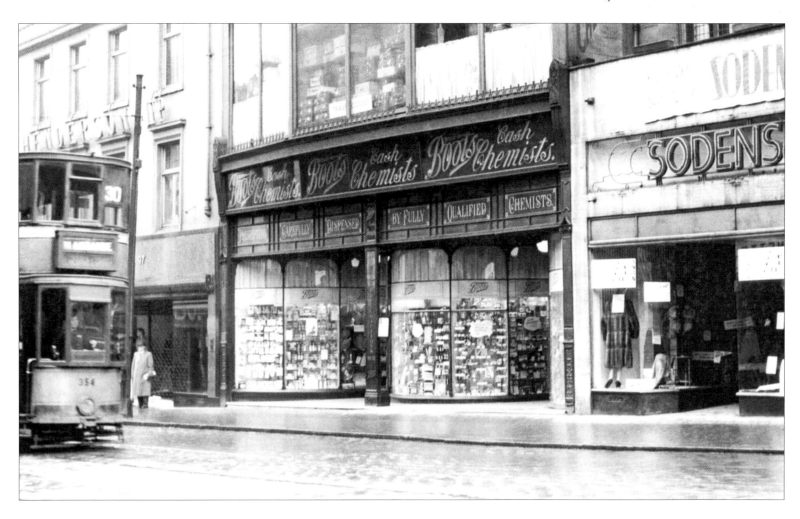

The Marks & Spencer story began when Russian born, Polish refugee, Michael Marks opened a stall in Leeds open market – a trestle table 6 ft x 4 ft. When a covered market that traded throughout the week opened in Leeds, Michael moved to a stall there, which, by drawing a chalk line down the centre, he divided into two sections, one displaying goods all costing a penny and the other goods costing more. Above the penny section was a notice 'Don't Ask the Price – it's a Penny'. That was the start of the famous Penny Bazaars.

By 1894 the business had become too large for one man to control and Tom Spencer became a partner, forming the most famous partnership in British retailing history – Marks & Spencer Limited.

In 1904 the company realised that its future lay in shops and not market stalls and by 1914 it had opened 140 shops. The first one in Glasgow opened in 1919 at 25 Argyle Street. This was replaced in 1930 by a purpose-built store just west of the original store. Today's massive store in Argyle Street is bounded by Glassford Street and Virginia Street. In 1935 a new branch of Marks & Spencer was opened in Sauchiehall Street in an Art Deco style building that has been replaced by the present store on the same site.

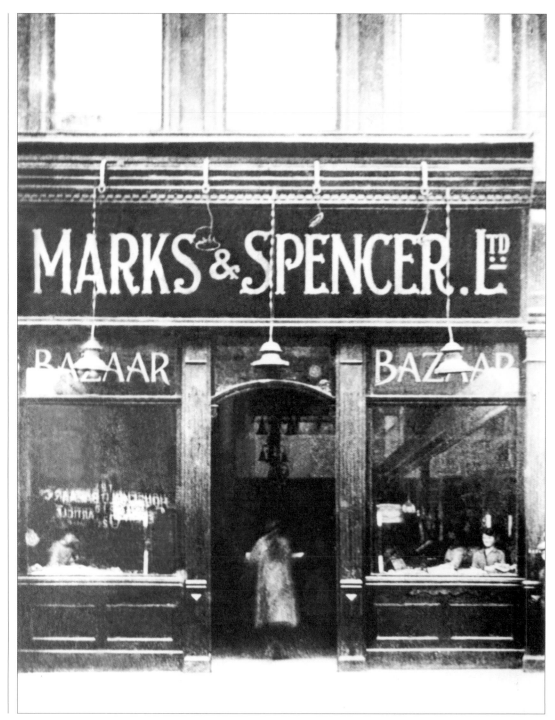

✿ This rare photograph shows Marks & Spencer's first shop in Glasgow. Although the company had moved on from its market stalls, it was using the word 'Bazaar' on its shop fronts.

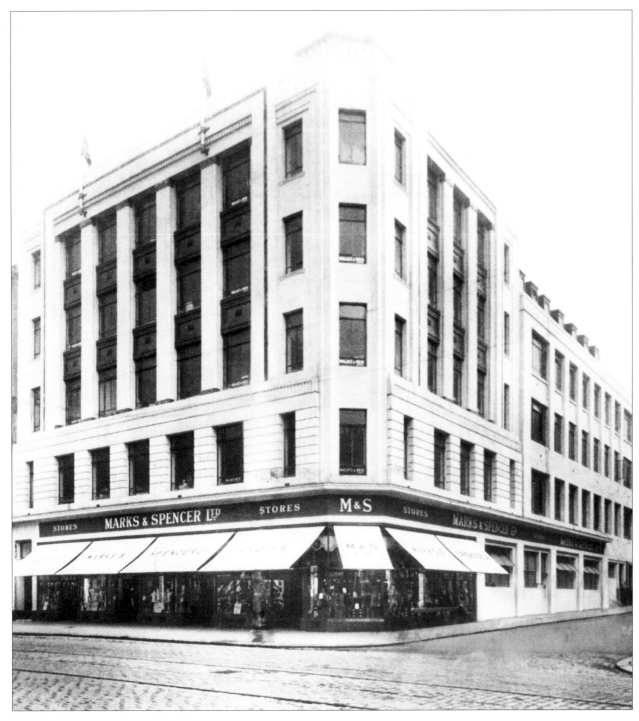

This photograph shows the impressive Marks & Spencer store at 18–26 Argyle Street that replaced the original small shop in 1930.

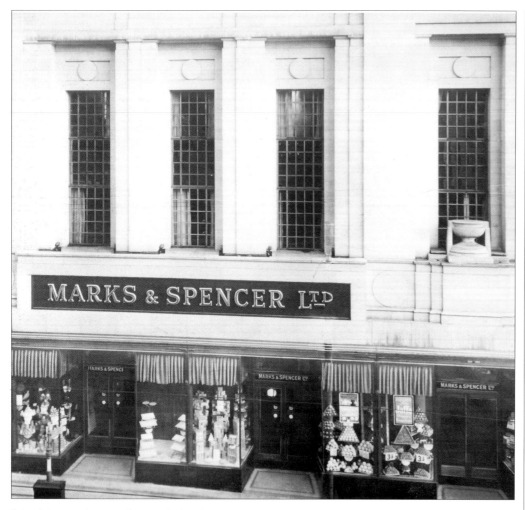

The Woolworth's story began when Frank Winfield Woolworth pioneered a chain of walk-around, open-display type stores in America. In 1909 Liverpool got the first British Woolworth's, which created a sensation, and by 1912 Woolworth's had a chain of 28 stores. Everything carried a plain price tag, each item costing a penny, threepence or sixpence.

Woolworth's was inundated with letters from local authorities asking the company to open a 'Woolies' in their town and in Glasgow, the first, and largest store, opened in the 1920s in Argyle Street. Stores at Charing Cross, Union Street and Sauchiehall Street followed.

By the late 1970s Woolworth's was trading unprofitably and in the 1980s many stores were closed leaving just one in Glasgow at the corner of Argyle Street and Jamaica Street. When Woolworth's went into administration in 2009, this store closed at the end of December.

This is another rare photograph that shows Marks & Spencer's shop in Sauchiehall Street when it opened in 1935. *All photographs courtesy of The Marks & Spencer Company Archive*

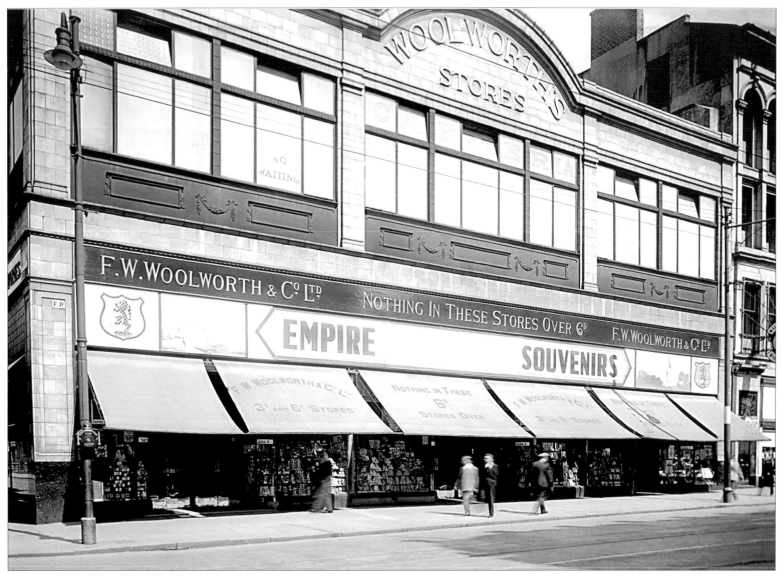

Woolworth's first store in Glasgow is shown here in 1938 when it was advertising souvenirs of Glasgow's Empire Exhibition being held in Bellahouston Park. The shop stated that it sold nothing over 6d, which was not true as often things cost more than that. The Art Deco style store was replaced in the early 1960s with a cheap modern building.

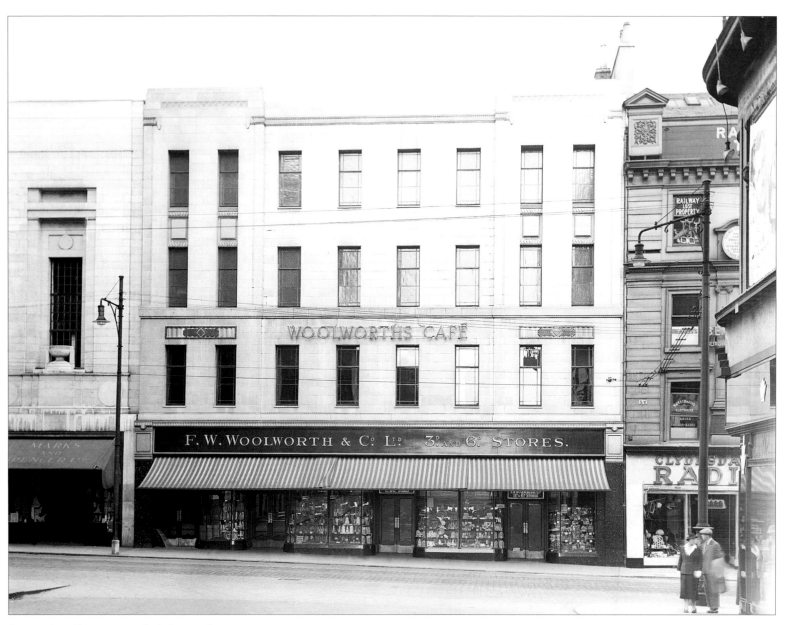

🙞 Woolworth's store in Sauchiehall Street shown
here in 1936. On its left is the newly built Marks &
Spencer store. *Courtesy Glasgow Regional Archives*

PART 5
Department Stores

Frasers is Glasgow's most prestigious department store and one of only two of the city's great department stores from the past to survive, the other being Watt Brothers. Frasers was founded by James Arthur and Hugh Fraser who formed a partnership in 1849 to open a drapery shop in Buchanan Street trading as Arthur & Fraser. Hugh Fraser had been apprenticed to Stewart & McDonald Ltd, a Glasgow drapery warehouse where he had risen to the position of warehouse manager. James Arthur already owned a retail drapery business in Paisley. The Glasgow Herald of 17 October 1849 announced the opening of 'a new silk mercery, linen and woollen drapery establishment at 8 Buchanan Street.' The advertisement also explained the partners' trading policy: 'In soliciting a share of public patronage, Arthur & Fraser respectfully intimate that they intend conducting their business exclusively on cash principles. In thus avoiding the expense and risk connected with the credit-giving establishment, it will

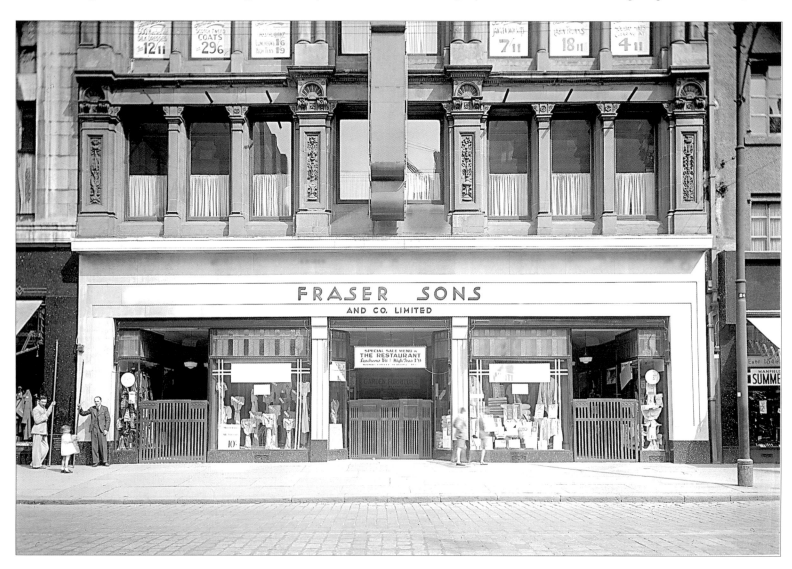

be in their power to adopt a scale of profits not attempted hitherto in Buchanan Street.'

Arthur & Fraser quickly expanded the business and established a wholesale trade in adjoining premises in Argyle Street. In 1856 the wholesale business moved to a larger site in Miller Street and it became a separate part of the company under the name of Arthur & Co. Meanwhile the retail side of the business expanded into the vacant buildings left by the movement of the wholesale side. In 1865 the partnership between Arthur and Fraser was dissolved with Fraser assuming control of the retail business and Arthur of the wholesale side. In 1865 Alexander McLaren joined the retail business and the name was changed to Fraser & McLaren.

When Hugh Fraser died in 1873, his three eldest sons, James, John and Hugh acquired stakes in the business. As they were minors when their father died, trustees looked after their interests until they came of age. When old enough, James and John, initially with Alexander McLaren and later

Opposite. Photograph, *c.* 1930, of Frasers in Argyle Street which reached through to Buchanan Street with a frontage on the opposite side of the street from today's store. *Courtesy Glasgow Regional Archives*

Left. Photograph showing the interior of Frasers decorated for Christmas in 1986. The galleries were designed by architect James Sellars for Wylie & Lochhead, whose store Frasers bought.

John Towers as managing partners, directed the business by then called Fraser & Sons. In 1891 Hugh joined the partnership. By 1900 Hugh Fraser II had assumed control, forming a private company Fraser & Sons Ltd in 1909.

After Hugh Fraser II died in 1927, his son Hugh Fraser III became chairman. He opened new departments and a restaurant and began to look at possible acquisitions. The first was in 1936 when Fraser purchased Arnott & Co. Ltd in Jamaica Street along with its neighbour Robert Simpson & Sons Ltd at the corner of Argyle Street and Jamaica Street. The two businesses were merged creating Arnott & Simpson. The start of this expansion was to develop to such an extent that between 1936 and 1985 over 70 companies, not including their subsidiaries would come under the Fraser umbrella.

In 1951 the company purchased McDonalds Ltd in Buchanan Street, which retained its original character until it was linked with Wylie & Lochhead next door, also acquired by Fraser. Renamed McDonalds, Wylie & Lochhead, a further merger with Fraser & Sons created one store, Frasers.

On 17 October 2009 Frasers in Buchanan Street celebrated its 160th anniversary. As part of the celebrations, on 15 October the store's longest serving employee, Stuart Wilson, who had been at the shop for 43 years, released 160 balloons into the sky at 2 p.m. Inside each balloon was a prize voucher worth up to £160. On the anniversary day, Saturday, the store held a 'One Day Only' event, when customers were able to secure huge discounts on one-off items, including designer handbags and televisions.

Photograph *c.* 2009 showing Frasers' terracotta clad frontage. *Photograph by Alan Ferguson*

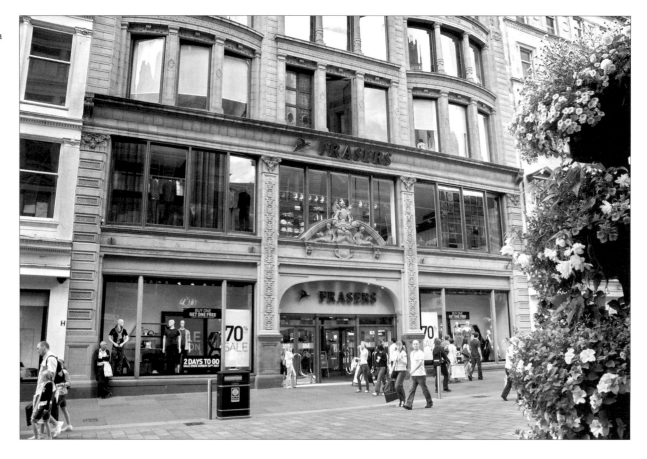

Watt Brothers in Sauchiehall Street is Glasgow's last family-owned independent department store. The business was started by Allan Watt, one of five sons of a Lanarkshire farmer, who decided to start a small drapery business in Larkhall in the early 1900s. The business developed so rapidly that he and his brothers moved into the city where they opened a shop in Elmbank Street. Their new business quickly became successful and 1915 they built the now famous shop at the corner of Sauchiehall Street and Hope Street. There, Watt Brothers became noted for blouses, with customers coming from all over Scotland to choose from the vast selection offered. Dresses were introduced later and gradually Watt Brothers began to take shape as a fashion house. In 1929 the buildings in Hope Street, Sauchiehall Lane and Bath Street were purchased and demolished and a new four-storey building with basement was built on the site. The new building housed three new departments, coats, costumes and millinery. Over the years these departments prospered until Watt Brothers became 'Famous for Fashion', the advertising slogan used in their advertisements for many years.

Later came 'Scotland's Leading Fashion House'.

In 1938, Allan Watt, the grandson of the founder joined the family business and at that point the founder, his son William and his grandson all worked there. In the late 1950s a new business 'Jean Paton' was opened in Hope Street, which within a few years became known as the leading Wedding House in Scotland. 'Going Away' outfits for the bride were a speciality.

In 1979 Watt Brothers became the location for TV's mini-series *Tinker, Tailor, Soldier, Spy* starring Sir Alex Guinness when its grand Czech marble staircase in the basement became the centrepiece for various scenes. Filming was done over a weekend and Hope Street was closed on the Sunday and covered over with rubber cobblestones. Signs relating to Glasgow were replaced with Czech signs.

Apart from shrewdly adapting its business to the times, part of Watt Brothers' success is that it pays no rent on the imposing property, the Watt family having owned the building since it first set up shop there.

Watt Brothers photographed in 1915 when it had just been built. Later the buildings to the left were purchased then demolished to make way for an extension to the store. It must have been a nightmare dressing the windows as they are crammed from top to bottom with goods.

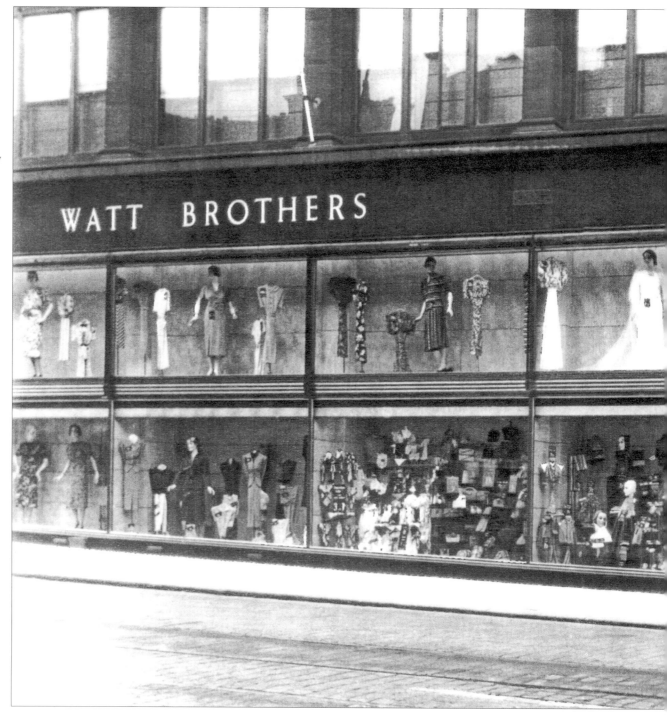

1930s view of the Hope Street façade of Watt Brothers. If the window displays are anything to go by, it must have been one of Glasgow's best fashion establishments. The upper showcase windows display beautiful evening and day dresses, all with lots of space around them to show them to advantage. The lower windows display general fashion items such as dresses, blouses, handbags, gloves and scarves.

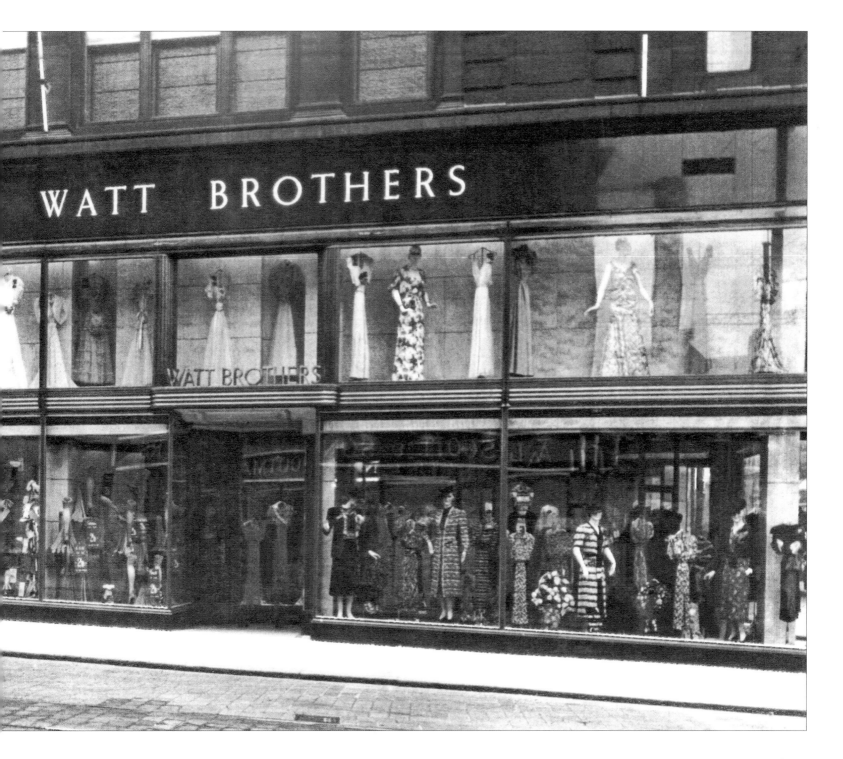

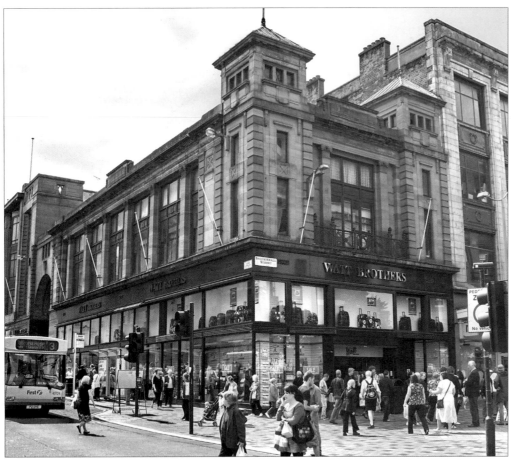

✤ *Above.* Watt Brothers photographed in 2010.
Photograph by Alan Ferguson

✤ *Opposite.* This illustration shows John Anderson's original shop in Clyde Terrace, his Jamaica Street Polytechnic and his vast Polytechnic in Argyle Street. The Jamaica Street store with its lofty showroom surrounded by tiers of galleries in the French style was the first of its kind in Scotland.

For decades Glasgwegians' favourite department store was Lewis's in Argyle Street. Some people, however, are old enough to remember when, instead of being known as Lewis's, it was affectionately called 'The Poly'. To find out the reason for this we have to go back to 1837 when John Anderson opened a small drapery shop in Clyde Terrace in the Gorbals. Business was so successful that he moved a year later to larger premises in the same street. His philosophy was that a quick turnover was more important than mark-ups, and to this end he bought 'remainder' stocks from manufacturers at huge discounts which he advertised in the local press as 'wagon loads of new bargains'. He was the first to use the gimmick of persuading people that they were not spending a shilling, just 11½d, or not a pound, just 99p as we know it today.

In 1845 Anderson put into operation his innovative plan of selling all kinds of goods under one roof, earning him the title of 'universal provider' and making him a pioneer of department store trading. Selling anything from toys to patent medicines, his tactics caused hostility from rival retailers. Customers, however, flocked to his store. On sale days crowds of shoppers blocked Clyde Terrace entirely, so Anderson moved to Jamaica Street's Polytechnic Rooms where again business boomed. The store became known as the Royal Polytechnic Warehouse, 'the Poly' for short. Moving into premises in Argyle Street in 1866, Anderson took the Polytechnic name with him and immediately his new establishment thronged with customers from morning to night.

Anderson often went on buying trips to France where there was a standstill in trade. There he bought bargain stock from bankruptcy sales and ex-display stock from exhibitions. In 1867 at the Paris Exhibition, he bought so much Austrian merchandise that the Austrian ambassador wanted to give him a medal, an offer he declined.

At the firm's Jubilee Banquet in 1877, Anderson startled his guests by telling them that when he began in business he had survived on less than sixpence a day. It was the first large banquet in Glasgow to which women were invited. Eventually, Anderson's magnificent emporium, which included hairdressing salons, a Byzantine Gentlemen's Smoke Room and a luxurious ladies' rest room adjacent to the Louis XVI Restaurant, occupied all the ground between Dunlop Street and Maxwell Street.

In 1929 Anderson's son sold the business to Lewis's who demolished the old building and in 1932 erected the largest provincial department store in Britain. Lewis's was part of a group of ten stores owned by the David Lewis company whose founder David Lewis opened its first store in Liverpool in 1856.

Glaswegians took to Lewis's immediately, as apart from it having the most comprehensive and varied stock, prices were kept as low as possible. The most popular place in the store was the fantastic toy department on the third floor. Just to visit it was a treat for children. Despite the new building and owner, however, people still spoke of the 'Poly' instead of Lewis's.

Each year Lewis's held its Christmas Fairyland, and all the ground floor windows

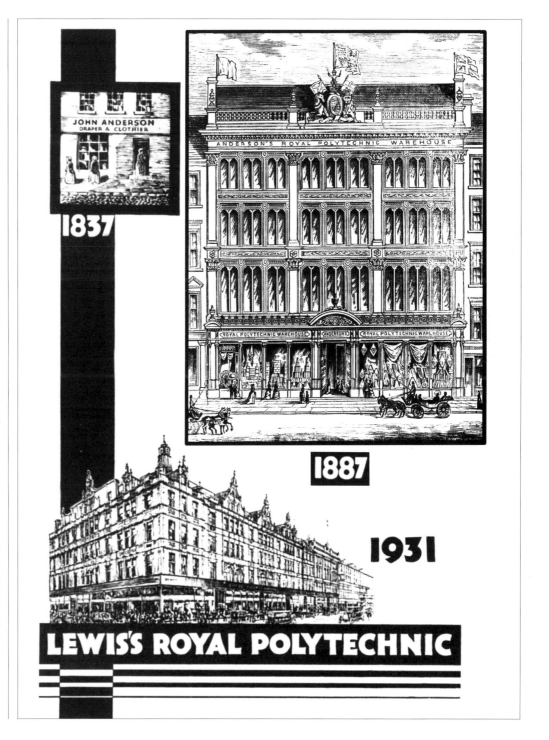

were spectacularly decorated with mechanical scenes from fairy tales. Thousands viewed them and Lewis's was continuing a tradition started by John Anderson who had decorated his store for Christmas for the first time in 1851. Each year his decorations became more extravagant, culminating in 1882 with a mechanical representation of the bombardment of Alexandria and the Battle of Tel-el-Kebir. Not very Christmassy, but it brought in the crowds who had to pay a small charge for the privilege of viewing it, the proceeds being donated to local charities.

Sears took over the company in 1965 and in 1986 the stores were subject to an internal management buy-out. On taking control, the new team decided refurbishment was needed and the Argyle Street store was chosen to be the first. When it reopened the ground floor had been sub-divided into small retail units. Despite the refurbishment, the new Lewis's failed and in the late 1980s Debenhams took over the store and the much loved Lewis's name vanished from Argyle Street.

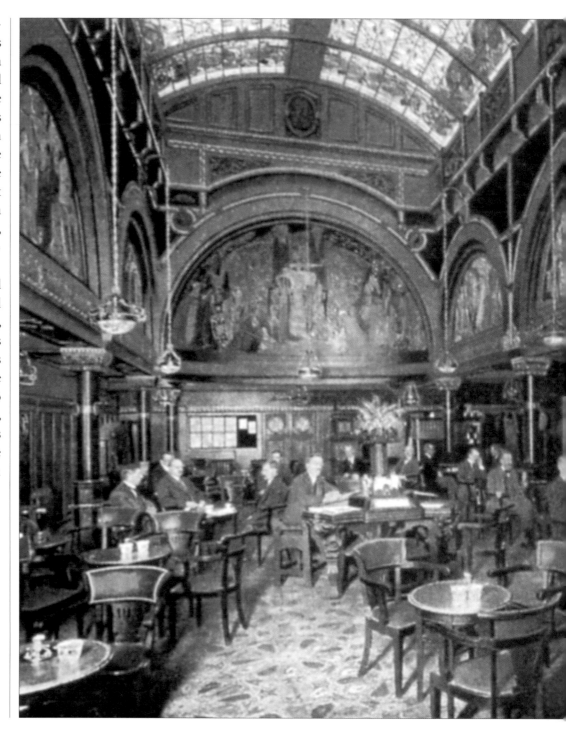

❧ *Right*. The Polytechnic's ornate Byzantine Gentlemen's Smoke Room.

❧ *Opposite top right*. Lewis's photographed in the late 1980s just before it closed.

❧ *Opposite below right*. Lewis's advertisement for boys' clothing in 1934.

❧ *Opposite below centre*. Advertisement, *c*. 1922, for the Polytechnic's Louis XVI ladies' rest room.

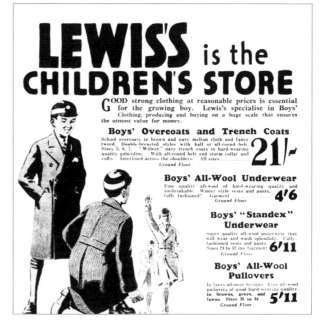

People still remember Pettigrew & Stephens' popular department store in Sauchiehall Street, which sold a wide range of goods including clothes, millinery, carpets, furniture and china.

Andrew Hislop Pettigrew and William Henry Stephens founded the company. Pettigrew had moved to Glasgow from New Lanark in 1875 and was employed in several of the city's largest drapery and general warehouses such as Copland & Lye and Anderson's Polytechnic (later Lewis's). In 1888 he purchased the stock and goodwill of an existing business in Sauchiehall Street, in partnership with William Henry Stephens. The drapery store comprised a small corner shop and upper flat. As the business prospered it expanded into adjoining property until the partners had a large store called Manchester House. When a tea-room was opened in 1895 it was advertised as a cosy resting place at the disposal of country visitors where light refreshments could be had. At first it was on a complimentary basis but after considering comments from customers, a moderate charge was introduced 'to remove all idea of indebtedness from the minds of patrons.'

❧ The new Manchester House, designed by Honeyman & Keppie, that opened in 1901. 'Next to the Exhibition', announced the firm's advertisements, 'Pettigrew & Stephens' great warehouse and department store is the sight of Glasgow.' The gilt dome was originally designed by Charles Rennie Mackintosh for a chapterhouse. An advertisement that appeared in the 1901 International Exhibition catalogue mentioned the store's unique features including a view tower from which the whole city could be seen.

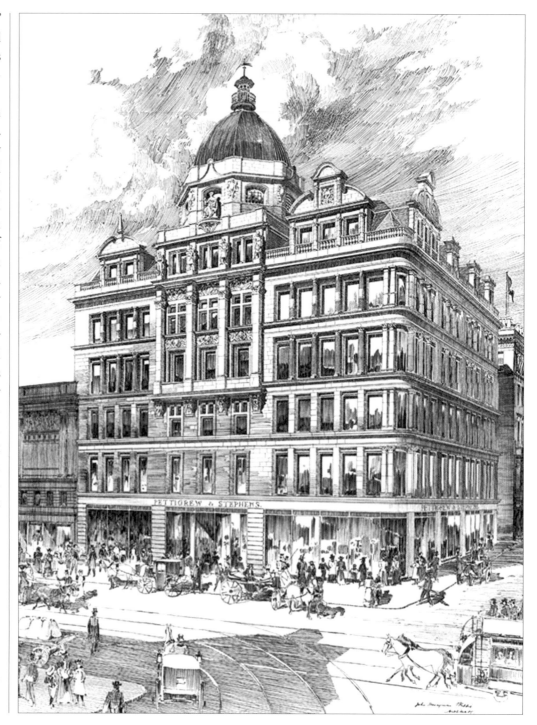

Having become the sole proprietor when Stephens died in 1895, Pettigrew began a major rebuilding of Manchester House, creating a French Renaissance building, designed by Honeyman and Keppie with a dome by Keppie's assistant, Charles Rennie Mackintosh.

The rebuilt store opened in May 1901 with seven floors of departments ranging from silks to confectionery and carpets to china. It was one of the most diversified and stylish stores in Scotland with elevators serving every floor. As well as the sales departments, there were reading rooms, a ladies' rendezvous, and tea and luncheon rooms. Ladies were invited to inspect the model kitchens.

In 1904 when Pettigrew converted the business into a limited company, the store was one of the largest in Scotland employing around 600 staff. The company continued to expand and in 1909 it took over J.J. Burnet's splendid Fine Art Institute lying between it and rival Copland & Lye's store. This part of the building was badly damaged by fire in July 1963.

In the early 1920s Pettigrew & Stephens created new men's departments with separate back entrances to their smoke and lunch rooms. Shopping then was still much of a segregated business. The smoke room was hired out for 'Smokers' Evenings' – all-male gatherings, often with some entertainer or a speaker.

Pettigrew & Stephens was subsequently acquired by the House of Fraser who closed the store in 1970. Shortly after the building was demolished the site became part of the ugly Sauchiehall Street Centre. Macintosh's dome finial was saved and was exhibited at the Garden Festival in 1988.

Above. Pettigrew & Stephens' Georgian tea and luncheon rooms, described as a place where a weary shopper might take tea or rest awhile in a lounge so artistically designed, so tranquil and agreeable to tired eyes that it was a cheerful and bright place for a chat.

Right. Fashion advertisement, c. 1935, for £5 ladies' coats at Pettigrew & Stephens. According to the advertisement they were no ordinary £5 coats but superior well-tailored garments enhanced with good quality furs.

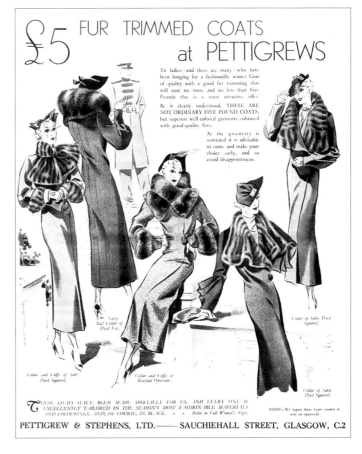

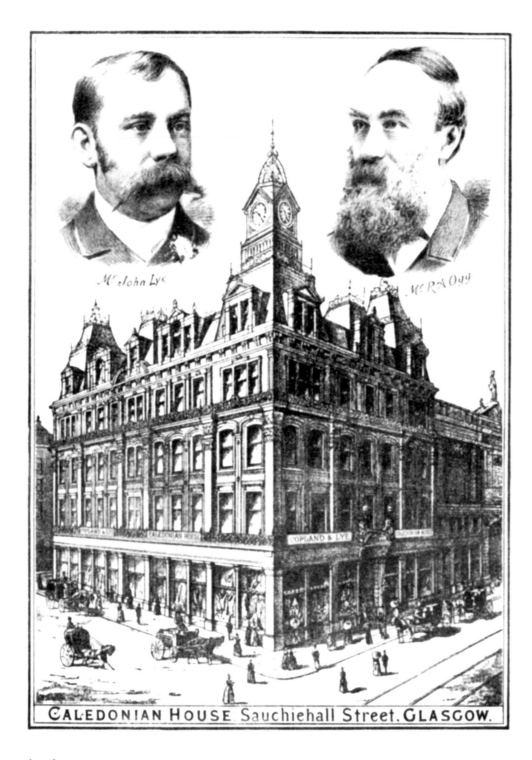

CALEDONIAN HOUSE Sauchiehall Street. GLASGOW.

Next door to Pettigrew & Stephens was its rival Copland & Lye, founded in Cowcaddens in 1873 by William Copland and John Lye. Within five years their business had developed to such massive proportions that in 1878 it moved into premises in Sauchiehall Street, Glasgow's up-and-coming shopping thoroughfare. Designed by James Boucher, the French Renaissance style store, named Caledonian House, was described as one of the most extensive, most architecturally elegant and the most perfectly-equipped drapery emporiums to be met with in the kingdom.

In 1884 William Copland died, followed three years later by the death of John Lye and one of his sons. The establishment was then run by John Lye, son of the founder and Robert A. Ogg.

The business continued to grow and an idea of its vast development can be formed from the fact that instead of the 20 assistants it first employed, by the end of the 1880s it had around 400. The major contribution to the success was the philosophy written into

✌ *Left*. A drawing of Caledonian House, *c.* 1890, showing its proprietors at the time, John Lye, son of the founder and Robert A. Ogg. Crowning the building is a three-faced clock that was later removed from the top and erected on the front of the Wellington/Sauchiehall Street corner of the building. When the store was demolished in 1971, the clock was given to Milngavie Town Council who restored it and in 1981 erected it, mounted on a platform, in the shopping precinct.

✌ *Opposite*. Copland & Lye advertisement for the latest styles of dresses in 1888 – not clothing for the poor but for West End ladies who shopped in Sauchiehall Street, not Argyle Street.

the firm's brochure and staff manual, 'Good merchandise is useless without good service … Small transactions well executed lead to big ones.'

While the exterior of Caledonian House, which was remodelled and extended in the 1890s, was imposing, the galleried interior was no less so. The spectacular stairwell gave splendid views of lofty well-lit departments displaying every kind of drapery imaginable as well as carpets, curtains, furniture and fancy goods. In 1890 the store advertised its Grand Christmas Exhibition that included a Childrens' Parade, The Home of the Fairies and the Enchanted Castle of Santa Claus.

While most department stores had a tea-room and restaurant, Copland's was special as theirs was situated round the stair-well from where customers could watch people doing their shopping. Copland's offered live music at tea-time and, as it had its own orchestra, shoppers could browse listening to the strains of music. As well as the tea-room there was a café for smokers and the restaurant for non-smokers. In the 1960s it was said that the recipe for Copland's famous pineapple cakes had remained unchanged for almost 100 years.

Department stores' tea-rooms and restaurants were used to show the latest fashions with models parading round the tables. In Copland's in 1947, the fashion show included luxury clothing by top designers such as Schiaparelli and Balmain, a treat to see after the utility clothing of the war years.

Copland & Lye was one of the few stores in Glasgow not to become part of the House

This elegant Bonnet is in roses and buds with leaves of two shades; the aigrette consists of buds and foliage.—*The Queen.*

Girl's Coat, made in a variety of materials, such as cloth, velvet, plush, tweed, &c.—*The Queen.*

Dark moss ottoman silk Bodice, brocaded with old-pink. Upright collar, waistcoat and under-sleeves in pink faille, veiled with cream lace. Bow in pink gauze ribbon, striped with satin and moire silk.—*The Queen.*

Plain and plaid tweed Costume, in which pale stone and deep red predominate. The underskirt is entirely plaid, and is thickly pleated at the back. The tablier is draped at each side, and the bodice crosses over a plastron of plaid and fastens slantwise.—*The Queen.*

COPLAND & LYE, CALEDONIAN HOUSE, SAUCHIEHALL STREET, GLASGOW.

of Fraser. It belonged to the Ogg family. Although Caledonian House was demolished in 1973 to make way for the Sauchiehall Street Centre, the store had closed in January 1971 as, by the end of the 1960s with their astronomical overheads and changing shopping habits, department stores were finding it difficult to survive. As had happened to Pettigrew's store, Copland's was demolished to make way for the Sauchiehall Street Centre.

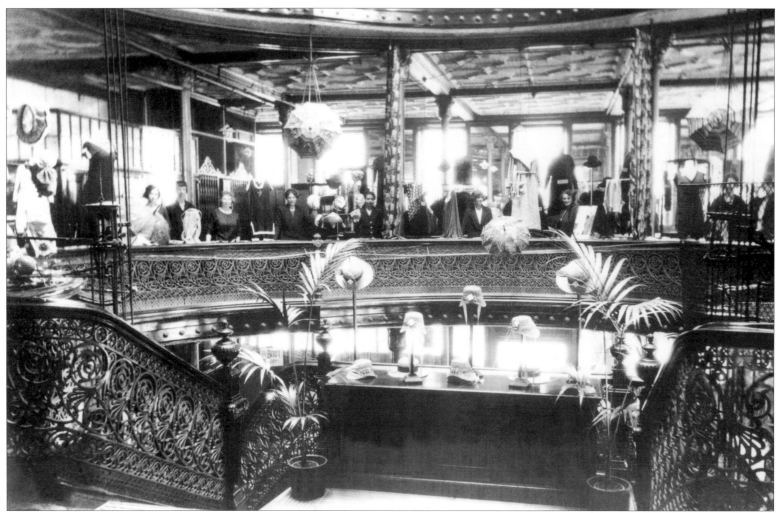

❧ Copland & Lye's magnificent stair well and gallery with staff lined up for the photograph, which was taken in the 1920s and in summer judging by the goods displayed – bathing costumes, straw hats and parasols. Parlour palms, which seem to appear in all old photographs of public buildings, add a botanical touch.

Tréron's in Sauchiehall Street was an off-shoot of Walter Wilson's Colosseum Warehouse in Jamaica Street. Believing that his building was threatened when the Caledonian Railway Company was authorised in 1901 to purchase property in Jamaica Street for the building of a new station, Wilson decided to open an emporium in the former McLellan Art Galleries in Sauchiehall Street, which had become the fashionable shopping thoroughfare in the city. As it happened, his warehouse was left untouched.

Wilson gave his new establishment a Parisian feel by naming it Tréron et Cie, Les Grands Magasins des Tuileries. (*Grands Magasins* means department store and the *Tuileries* was a royal palace in Paris.) When the warehouse opened in March 1904, its purpose was to supply drapery merchandise in exclusive designs and exquisite qualities at prices as low as those asked in other drapery warehouses for very ordinary goods. Wilson wanted to outrival in style, quality, and exclusiveness the great warehouses of London and Paris and so retain in Glasgow the orders of those ladies of the West of Scotland who otherwise would give the greatest part of their patronage to cities in the south.

In Tréron's (the shortened name) everyone was free to walk round the forty roomy departments and inspect the goods without pressure to buy. The floors were covered in rich carpets, and fittings and furniture were of the most modern and artistic design. The decoration of the luncheon rooms, tearooms, resting rooms and writing rooms, in white and gold in Louis XIV style, was

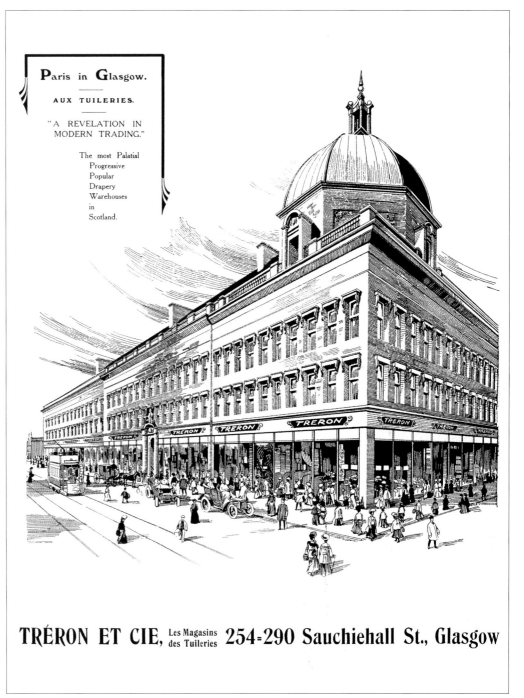

Paris in Glasgow.

AUX TUILERIES.

"A REVELATION IN MODERN TRADING."

The most Palatial Progressive Popular Drapery Warehouses in Scotland.

TRÉRON ET CIE, Les Magasins des Tuileries 254=290 Sauchiehall St., Glasgow

Drawing of Tréron et Cie in 1909.

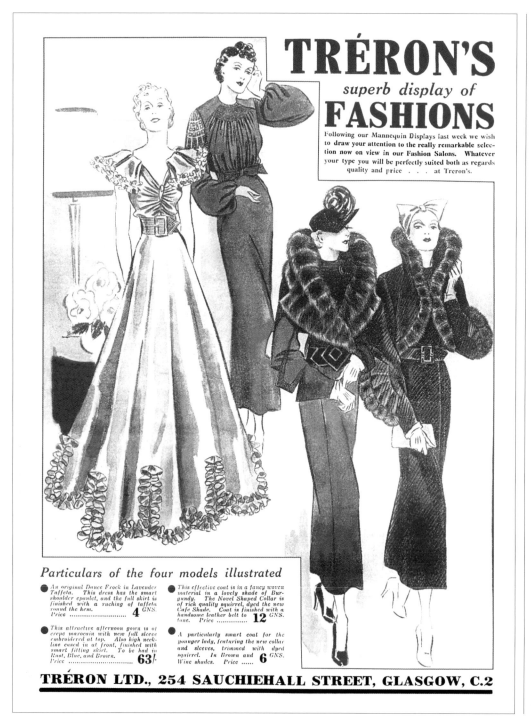

TRÉRON'S

superb display of

FASHIONS

Following our Mannequin Displays last week we wish to **draw your attention to the really remarkable selection** now on view in our Fashion Salons. Whatever your type you will be perfectly suited both as regards quality and price . . . at Tréron's.

Particulars of the four models illustrated

● *An original Dance Frock in Lavender Taffeta. This dress has the smart shoulder epaulet, and the full skirt is finished with a ruching of taffeta round the hem. Price* **4** GNS.

● *This attractive afternoon gown is of crepe marocain with new full sleeve embroidered at top. Also high neckline cased in at front, finished with smart fitting skirt. To be had in Rust, Blue, and Brown. Price* **63/-**

● *This effective coat is in a fancy woven material in a lovely shade of Burgundy. The Novel Shaped Collar is of rich quality squirrel, dyed the new Cafe Shade. Coat is finished with a handsome leather belt to* **12** GNS. *tone. Price*

● *A particularly smart coat for the younger lady, featuring the new collar and sleeves, trimmed with dyed squirrel. In Brown and* **6** GNS. *Wine shades. Price*

TRÉRON LTD., 254 SAUCHIEHALL STREET, GLASGOW, C.2

magnificent and while they were provided for the convenience of the patrons they were also open to the public who had the pleasure of listening daily to the Tuileries Ladies' Orchestra.

Tréron's sold more high-class millinery than any other warehouse in Europe. There were hundreds of models from the leading milliners of Paris, Vienna and other fashion centres. When cartwheel hats became the craze in Paris in 1908 a Glasgow newspaper made the following announcement: 'The big hat craze has come to Glasgow. Messrs. Tréron et Cie in Sauchiehall Street are today showing in their windows the very large models worn in Paris.' There were plenty of windows in which to display the hats, as the establishment had 48.

Walter Wilson was an innovator. In Scottish warehouses he was the first to inaugurate tea-rooms and to use electricity. He also introduced 'Forenoon Shopping' in Glasgow. For generations, the ladies of Glasgow had been accustomed to doing their shopping in the afternoon with the result that between the hours of two and five o'clock Sauchiehall Street and Buchanan Street were thronged with shoppers, meaning that staff had not much to do earlier in the day. In Tréron's, Mr Wilson inaugurated a scheme of forenoon shopping whereby he set aside specially purchased goods available only to those who arrived before twelve o'clock. The scheme was a resounding success as no sooner had the doors of the store opened than customers arrived from all parts of the city to get their bargains before the twelve o'clock deadline.

In 1913 Wilson introduced another innovation – 'the bargain basement', an institution new to Scotland but for years used with success in the great stores of New York, Chicago, Philadelphia and Toronto. It was already a feature of several large London stores.

Walter Wilson died in 1918 but Tréron's lived on until 1985 when the building was badly damaged by fire.

❧ *Opposite*. Advertisement, *c*. 1935, for Tréron's ladies fashions.

❧ *Below*. Treron's in 1977, eight years before the building caught fire.

Arnotts in Argyle Street was a store for all social groups and its closing in 1994 was the end of a Glasgow trading tradition that stretched back almost 150 years. The store grew out of the drapery and general warehouse business in Jamaica Street established around 1850 by John Arnott, a Dublin merchant who had businesses in Cork, Belfast and Dublin. Trading as Arnott, Cannock & Co, the shop sold dress materials, towelling, sheets, linens, blankets, quilts and counterpanes. The business quickly expanded, offering ready-made clothing and developing a reputation for adventurous salesmanship and bold advertising. In September 1860 the partnership between Arnott and Cannock was dissolved and Thomas Arnott, John's half-brother assumed control of the Glasgow business, which began trading as Arnott and Co.

The next decade saw an aggressive development and expansion programme and by 1872 the firm, selling goods ranging from shawls and parasols to carpets and haberdashery, was describing its warehouse as 'the largest retail drapery establishment in the city.' In 1874 new costume galleries were opened and premises were acquired in Adam's Court Lane.

At the end of 1881 Arnott embarked on an extensive refurbishment programme and when the new warehouse opened in 1882 it was described in the local press as 'one of the finest and most commodious in the city.' The shop front, featuring two huge plate glass windows, caused particular interest. Each twenty-foot-broad window was divided into three panes and the spans were

considered to be possibly the largest ever attempted in warehouse architecture. In 1885, the store became the first warehouse in Scotland to install an automatic cash carrier, the Lamson cash railway, its purpose being to convey the money received in payment of goods safely, promptly and accurately from any part of a large warehouse to the cashier's box, and to expeditiously return the change, if any.

When Thomas Arnott died in 1883 his half-brother John acquired his shares and in 1891 Arnott & Co Ltd was incorporated as a private limited-liability company.

Although Arnotts traded successfully for decades, its fortunes began to waver during the depressed inter-war years when it experienced severe cash-flow problems. In 1936 the store recorded a loss of £272 and in May that year it was acquired by Fraser, Sons & Co. Ltd. A new company Arnott and Co. Ltd was incorporated with Hugh Fraser and his family as principal shareholders. By September, Fraser had acquired the neighbouring store of Robert Simpson & Sons Ltd, established by Robert Simpson as a shawl warehouse in Trongate in 1825, which had moved to Jamaica Street in 1851. In 1938 the extended emporium was renamed Arnott Simpson Ltd. As Robert Simpson's store occupied the entire Jamaica Street/Argyle Street corner, the site was known for decades as 'Simpson's Corner'.

On the morning of 3 February 1951 a fire destroyed half of the Arnott Simpson building. While the store was rebuilt in the early 1960s on the original block, it did not include the Jamaica Street corner site. The new store was more than double the size of the previous building and it opened in April 1963 called simply Arnotts.

While Arnotts continued to trade successfully and in 1987 was totally refurbished, the House of Fraser decided that it was uneconomic to operate Arnotts and Frasers so near to each other. The decision was made to close Arnotts, which happened on 26 February 1994. The building was sold to a property company which split it into separate retail units.

🙵 *Opposite*. Arnott & Co's warehouse in Jamaica Street in the 1890s.

🙵 *Below*. Photograph of Arnotts' new store in Argyle Street, which opened in 1963.

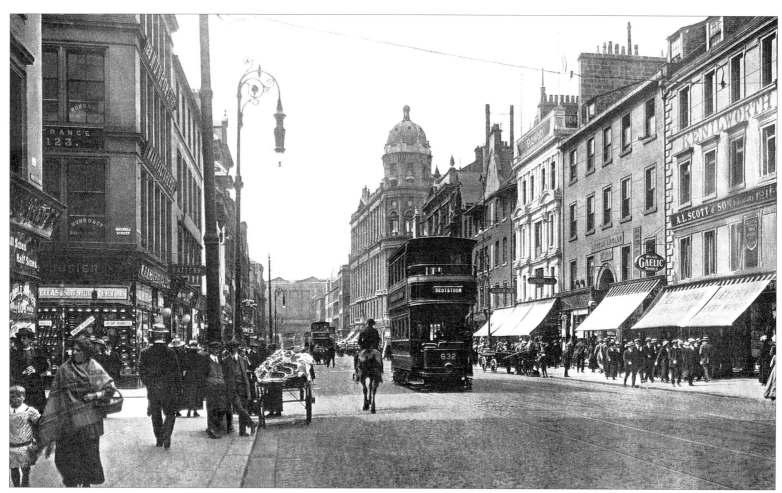

Argyle Street around 1918 looking west. Apart from the tramcars, the horseman and the dress of the people, the view is much as today as none of the buildings have changed. To the right, the building in between the sun canopies is the Argyll arcade. The photograph must have been taken in summer as many people are wearing boaters. While the lady to the left in the foreground is wearing a shawl, the little boy is fashionably dressed.

INDEX OF SHOPS